S0-BBY-642

09/24
STRAND PRICE
$ 5.00

The Kosciuszko Foundation, Inc.
15 East 65th Street
New York, N.Y. 10021

Copyright © 1995 by The Kosciuszko Foundation, Inc.
No part of this book may be reproduced in any form without the
permission of the copyright holder

LIBRARY OF CONGRESS CATALOG CARD NUMBER: 95-79066
 Polish Masters from The Kosciuszko Foundation Collection

ISBN Hardcover 0-917004-23-V
ISBN Softcover 0-917004-24-8

FRONT/BACK COVERS : *Gamrat and Stańczyk* by Jan Matejko

PRODUCTION EDITOR: Elizabeth Koszarski-Skrabonja
ENGLISH TRANSLATION: Prof. Harold B. Segel
PHOTOGRAPHY: Bruce Schwarz
ARCHITECTURAL
PHOTOGRAPHY: Christopher Gore
DESIGN: O&J Design, Inc., NY

Printed and bound in Hong Kong

❧ TO THE MEMORY OF PROF. STEPHEN P. MIZWA

The publication of this book was made possible by major gifts provided by:

The Alfred Jurzykowski Foundation

The John Edmond Kierzkowski Revocable Trust

The National Endowment for the Arts

Attorney Joseph E. & Eugenia Gore

Dr. & Mrs. Tadeusz Sendzimir

Mr. Tom M. Podl

Dr. & Mrs. Thomas H. Lesnik

Polish American Cultural Society of Stamford, Inc.

The following donors are also gratefully acknowledged:

Mr. John T. Nocket

Miss Gertrude & Miss Margaret Stachelski

Mrs. Charlotte Baran-Wiener

The Polish National Alliance of Brooklyn (women's department)

The Polish National Alliance of Brooklyn

Mr. & Mrs. Walter Dabkowski

Dr. & Mrs. William Wladecki

Mr. & Mrs. Richard Wiedman

Miss Helen Mayek

Dr. Władysława Jaworska is an art historian and professor at the Institute of Art of the Polish Academy of Sciences in Warsaw. She is the author of over 150 publications, specializing in Polish and European art of the 19th and 20th centuries. She has served as president and is currently honorary president of the International Association of Art Critics. Dr. Jaworska has been awarded the distinguished Polish Cross Polonia Restituta and the French order of Chevalier de la Legion d'Honneur.

❧ TABLE OF CONTENTS

FOREWORD

The need for this catalog has become increasingly apparent in recent years as awareness of our once rather cloistered collection of artworks has steadily grown. Many individual pieces have lately traveled to exhibitions at other institutions in the United States and Canada, while we at the Foundation have witnessed the gratifying response to our conservation program and our efforts to rethink and enhance the exhibition of the works in our own gallery.

If not the largest or most comprehensive gathering of Polish painting abroad, the collection of the Kosciuszko Foundation is undoubtedly one of the most important. Viewed, or at least seen, by thousands of visitors annually—those with business with the Foundation and those who come to attend one of the many cultural events at the Foundation House—the collection provides, because of its close proximity to New York City's great museums and galleries, a unique opportunity to consider Polish art within the larger context of the history of European and American art. It is in hopes of fostering a greater appreciation of our collection as an exceptional resource, and in keeping with the Foundation's fundamental mission of presenting the Polish cultural tradition to a wider American audience, that this catalog has been published.

The present collection honors the foresight of the many donors and the devotion and zeal of the Foundation's Polish founder, Prof. Stephen P. Mizwa. He recognized early the value of such a collection and offered the Main Gallery of the Foundation House as an exhibition space, and he encouraged the purchase of particularly appropriate and important pieces by patrons who subsequently presented them to the Foundation.

The first work in the collection, the portrait by Jan Czedekowski of Tadeusz Kościuszko at the United States Military Academy at West Point, was donated by the artist in 1947. For Professor Mizwa a portrait of the Foundation's namesake was a near necessity, and he was willing to wait for the right artist. Czedekowski's portrait was a just reward for his patience and set a high standard for the ensuing years of collecting. The collection has grown considerably since 1947, both in size and in stylistic breadth. Only a fraction of the Foundation's holdings could be reproduced in this catalog, but the full range of Polish art of the nineteenth and early twentieth centuries is represented—impressionism, realism, academic classicism, and symbolism.

The Kosciuszko Foundation wishes to thank all those who contributed to the collection and to the publication of this catalog and to acknowledge their splendid efforts to enhance and propagate Polish culture in the United States.

Joseph E. Gore, *President and Executive Director*
The Kosciuszko Foundation
New York, 1995

THE KOSCIUSZKO FOUNDATION AND THE FINE ARTS

In 1925 a group of seven distinguished persons* came together to establish the Kosciuszko Foundation. Originally intended to promote the exchange of scholars and students between Poland and the United States, the Foundation expanded its activities as new needs became manifest. The fine arts were an integral component of the Foundation's mission from the outset. One of the first exchange programs was the "Summer Course in Polish Art" organized for American art students at the Kraków Academy of Fine Arts in 1937 and 1938. During World War II, the Foundation sent, with the cooperation of the American Relief for Poland Committee, art supplies and assistance to Polish artists stranded in various parts of the world.

A PERMANENT HOME

With the acquisition of the Kosciuszko Foundation House in 1945 came an opportunity to establish and lodge a permanent collection of Polish masterworks in the United States. The House, at 15 East 65th Street in New York City, is an adaptation of a design by Robert Adam for a London residence built in 1772 by Sir Watkin Williams-Wynn. The New York structure was designed in 1917 for James J. Van Allen by Harry Allan Jacobs. Building on the classical-revival features of the original, Jacobs introduced new, individual elements while maintaining a stylistic integrity. The interior's circular entrance lobby opens immediately onto the upper floor by way of an elegant stairway graced with an ornate iron balustrade. On the second floor is a monumentally proportioned salon panelled in oak and detailed with intricate carving. Plasterwork rosettes and other flourishes mark the ceiling; the windows are finished with valances of eighteenth century Belgian tapestries, and a marble mantelpiece adds focus to the central fireplace. In this room the Foundation has installed its gallery of Polish Masters. In 1920 Van Allen sold the residence to Rufus L. Patterson, president of the American Machine and Foundry Company. The Kosciuszko Foundation came into possession of the building in 1945.

The Foundation House was formally opened with a commemoration of the bicentennial of Tadeusz Kościuszko's birth on October 17, 1946. The first exhibition was organized in March of 1947. It featured twenty-one portraits by the Polish artist Bolesław Jan Czedekowski. Czedekowski, who was aided by the Foundation following his arrival in the United States during World War II, was subsequently commissioned to paint a portrait of Tadeusz Kościuszko as an American military hero, dressed in the uniform of a brigadier general of the Continental army of the American War of Independence (plate no. 13). This portrait, which hangs over the mantle in the Main Gallery, was donated by the artist to the Foundation and was the first acquisition of the permanent collection.

* Willis H. Booth, vice president of Guaranty Trust Company of New York; Cedric E. Fauntleroy, commander of the Kosciuszko Squadron, which defended the Poles in Lwów at the end of World War I; Robert H. Lord, professor at Harvard University and advisor to President Woodrow Wilson on Polish affairs; Henry Noble MacCracken, president of Vassar College; Stephen P. Mizwa, associate professor of economics at Drake University; Paul Monroe, professor of education at Columbia University and educational consultant to the Polish government; Samuel M. Vauclain, president of the Baldwin Locomotive Works.

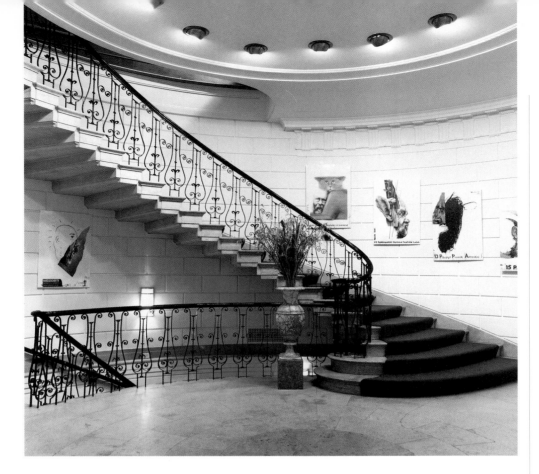

Rotunda and
Grand Staircase

THE GALLERY OF POLISH MASTERS

Polish art was unknown to the American public in the immediate postwar years. To provide a resource, in 1947 the Foundation, in cooperation with the Philosophical Library of New York, published Dr. Irene Piotrowska's *The Art of Poland*, one of the first studies of Polish art in English. Also in 1947, a series of annual exhibitions featuring Polish American artists was inaugurated. Judged by a panel of distinguished critics, the exhibitions were held until 1950. After this time, plans for a gallery became more ambitious.

Most of the major works in the present collection were acquired during the early 1950s. Prof. Stephen P. Mizwa, the director and subsequently the president of the Foundation, is credited with initiating the effort to gather together Polish masterworks for public view in this country. It is to his vision and tenacity that this catalog is dedicated. Major works by Polish artists were then available on the international market - paintings that had been in the hands of private collectors in the West. Poland at this time was virtually cut off from the West; cultural and intellectual exchange had ceased with the onset of the cold war. This isolation had a profound effect on Polish intellectuals in the United States.

Mizwa began to receive appeals urging the Foundation to involve itself in the preservation of Polish culture. Typical was one concerning paintings available for sale by a London collector, Antoni Maryanowski: "Save these works from destruction and dispersion and make it possible for Americans of Polish as well as non-Polish extraction to become acquainted with them. Despite many partitions, despite fire and sword over these past generations, there is still something left of our cultural treasures which serves as eloquent testimony of its antiquity, richness and universal quality."

Mizwa embraced these appeals. In November 1951, he wrote: "The Foundation, in view of the present, we hope temporary, situation in Poland, has shifted its emphasis to cultural activities here and is turning into an American Center for Polish Culture. One of our aims in the new program is trying to collect, preserve and make available to the public Polish cultural treasures of the past— especially paintings of Polish masters, as may be available." A flurry of correspondence ensued between Mizwa and collectors in Paris,

Vienna, London, Nova Scotia, Berlin, and New York. He followed the international art auctions. And he began to give thought to financing the collection he envisioned.

In many cases, works were crated and sent to the Foundation on loan and then exhibited in the gallery in the expectation that a patron would be found to purchase the piece for the collection. In other instances, Mizwa wrote directly to individuals who had expressed interest in donating a sum of money to the Foundation, suggesting that they instead purchase a particular painting, perhaps donating the piece in the memory of a family member. Gala presentation ceremonies were held. The call to complete the collection was met with passionate resolve by friends of the Foundation. By 1953, Mizwa had effectively completed his curatorial coup: most of the collection presented in this catalog had been assembled by that time.

A ROMANTIC VISION

If there was an ideological component to the curatorial decisions Mizwa made during the postwar years, it is important to note that the major works acquired were by artists of international repute, such as Jan Matejko, Jozef Brandt, Alfred Wierusz-Kowalski, and Jacek Malczewski. Too, there was an easy affinity between the contemporary concern with preserving Polish cultural treasures and the expressive intent of many of the works collected. Mizwa's decision to center the collection on works from the nineteenth century was not incidental. It was with the coming of romanticism that painting in Poland began to answer to patriotic as well as aesthetic concerns. During the period of the partitions, especially, artists became the repositories, purveyors, and heroes of a highly spiritualized national sentiment. This admixture of a melancholic and yearning nationalism with formal conventions drawn from a wider central European tradition has continued down to the present, and it was of great interest to Mizwa, especially in its earliest manifestations.

Historical or military themes served, of course, as ready vehicles for the expression of national feeling. Aleksander Orłowski (1777–1832) distinguished himself with dynamic compositions of this type. *The Battle* (plate no. 35) is a lithograph that celebrates Orłowski's interest in the cultures of Central Asia. From the images of Kościuszko that Orłowski produced, one inspired Jan Damel (1780–1840) to paint the monumental *Kościuszko Released from Russian Prison* (plate no. 14). This work is part of a large trove of Kosciuszkiana in the Foundation's collection.

Kościuszko at the Battle of Racławice (plate no. 38) by Jan Styka (1858–1925) along with *Peasants Capturing the Cannon at Racławice* (plate no. 39) are two full-scale sketches from the Racławice Panorama in the collection; the portrayal of Kościuszko as a national hero is reinforced here by his traditional dress of the Kraków region. *Kościuszko at West Point* (plate no. 13), by Bolesław Jan Czedekowski (1885–1969), presents Kościuszko again, this time as a hero of the American Revolutionary War. An emigre artist, Czedekowski was aided by the Foundation after World War II and had a close personal relationship with Mizwa. This work, although completed in 1947, reflects the sensibilities and practice of the nineteenth century. It was the first acquisition of the permanent collection.

The Polish landscape, its beauty and melancholy, has also served to express the spirit of Poland. Jan Chełminski (1851–1925) extends this impulse with a mythological touch in *His Last Vision* (plate no. 10). The painting depicts a dying Polish soldier, an officer of the Napoleonic army, in a nocturnal landscape. Out of the wood arises a specter, the personified spirit of Poland. Genre scenes - the lives of common people portrayed in a naturalistic and at times didactic manner - were also important in the latter half of the nineteenth century. Examples from the collection are *The Apple Orchard* (plate no. 27), by Franciszek Kostrzewski (1826–1911), and *Sisters of*

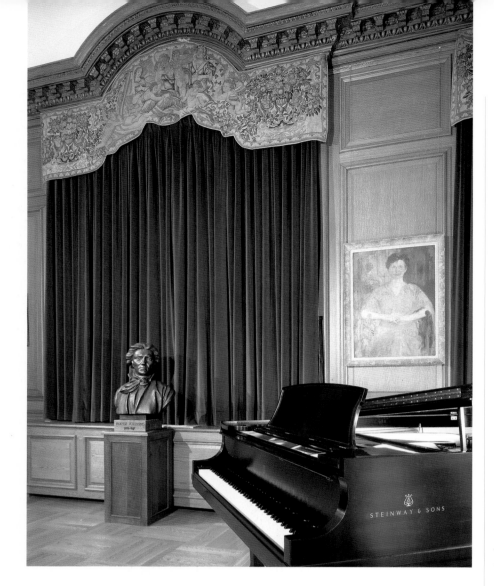

A corner of the Gallery of Polish Masters

Charity with Orphans (plate no. 17), by Antoni Gramatyka (1841–1922). Aleksander Kotsis (1836–1917) of Kraków was a sensitive observer of the Polish village and the highlanders. His *Polish Mountaineer* (plate no. 28) is a psychologically acute portrait rendered with a delicate hand in subdued colors.

Juliusz Kossak (1824–1899) was a master watercolorist who specialized in works on equestrian themes, of which *The Dzieduszycki Stable* (plate no. 24) is an excellent example. He was the head of an artistic family highly regarded by the Poles. His son Wojciech Kossak (1856–1942) is represented by *The Knight and the Maid* (plate no. 25) and grandson Jerzy Kossak (1886–1955) by *Polish Uhlan and Russian Cossack* (plate no. 26). Their intergenerational documentation of the Polish military creates a compelling narrative.

In the latter half of the nineteenth century, Polish painting developed abroad, as many artists joined a great cultural emigration, mostly to France and Germany. Some of these artists remained devoted to purely Polish themes, often idealizing their subjects in high-romantic fashion. They absorbed, however, the artistic techniques current in their adopted locales, perhaps adding a characteristically Polish touch. Władysław Bakałowicz (1833–1903) worked in France for most of his career and specialized in carefully rendered portraits and genre scenes on aristocratic themes, of which *Portrait of a Lady* (plate no. 4) is an example. Władysław Czachórski (1850–1911) enjoyed renown also in Germany for his almost obsessively opulent canvases. His *Young Lady at the Fireplace* (plate no. 12) shows the mastery of his technique.

A sizable colony of Polish artists had appeared in Munich by mid century, many of whom passed through the studio of Józef Brandt (1841–1915). Visually dramatic and aggressively controlled, Brandt's work often treats historical themes; *Light Cavalry - Lisowczycy* (plate no. 9) is a dynamic

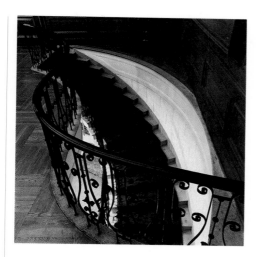

example. Władysław Szerner (1836–1915), after initial studies in Warsaw, spent his professional life in Germany. His *A Reconnoitering Expedition* (plate no. 41) is one of the Polish scenes that were his exclusive concern. The work of Alfred Wierusz-Kowalski (1849–1915) seems to exemplify the so called Munich school. His compact canvases, with their atmospheric nuance, offer the viewer a certain comfortable familiarity; they have been highly regarded throughout Europe. He is represented here by *The Horse Fair* (plate no. 30) and *On the Farm* (plate no. 29).

Considered the chief representative of Polish historical painting, Jan Matejko (1838–1893) raised the genre to a national importance rarely seen elsewhere. Living and working in Kraków throughout his life, Matejko mixed romantic, classical and realistic elements in canvases suffused with mourning over the loss of country. His *Gamrat and Stańczyk* (plate no. 34) is a historical tableaux dense with detail and meaning. Aleksander Gryglewski (1833–1879) was a close friend of Matejko's and often collaborated with him. A master of architectural perspective, as evident in *Interior of a Church* (plate no. 18) Gryglewski would work up the architectural elements and Matejko would compose the figures.

It was inevitable, however, that a reaction against Matejko's legacy would arise. The new trend toward naturalism was gaining. Not only did naturalism's brightened palette and gestural boldness entice Polish artists: the new

spirit in painting also offered an opportunity to return with freshened vision to the Polish landscape. At the crossroads during this period was Józef Chełmoński (1849–1914), first renowned for his paintings featuring wildly running teams of horses, such as *Country Fair* (plate no. 11). In time he became known as the first original interpreter of the landscape of the Polish plain.

An early proponent of impressionism, Julian Fałat (1853–1929) excelled in watercolor. Adopting the approach more than the palette of the impressionists, he maintained a rather traditional color scheme, as seen in *Saint Anne's Church in Warsaw* (plate no. 15). Leon Wyczółkowski (1852–1936) is an artist who embraced the new style through many mediums, celebrating Poland in each. *Saint Mary's Church in Kraków* (plate no. 43) displays his prowess in watercolor. His pastel *Poet's Sweetheart* (plate no. 44) has a literary connection as it is a portrait of Lucjan Rydel's bride. The treatment of folk motifs in a coloristically relaxed and light-drenched manner had enthusiastic proponents. Włodzimierz Tetmajer (1861–1923) and Apoloniusz Kędzierski (1861–1939) both worked in this vein, as seen in *The Harvest* (plate no. 42) and *The Old Oaken Bucket* (plate no. 23).

At the turn of the century, then, though there had been artistic breakthroughs, the political situation remained essentially unchanged for Polish artists, as for all Poles. The nation was still deprived of her political independence. Issues of vital concern were, in much of the country, impossible to address in an open manner. Symbolism, in painting as in literature, became a powerful vehicle for the expression of national ideals. Jacek Malczewski (1854–1929) painted fantastic allegorical figures inhabiting the Polish countryside, yearning for freedom. His brushstroke is broad yet controlled and his palette surprising—rose hues with yellow ochres boldly contrasted with black or brown. The compositions are strong, verging on abstract, as in *Self Portrait with a Black Hat* (plate

13

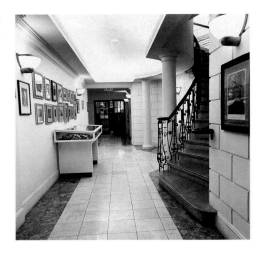

no. 32) and the melancholic *The Final Journey* (plate no. 33). Also working in a symbolist manner, although perhaps more to psychological than political ends, was Teodor Axentowicz (1859–1938). His keen interest in folk cultures is evident in *The Blessing of the Waters among the Hutzuls* (plate no. 2), which depicts a religious rite of a small ethnic group of southeastern Poland. *Spring and Winter* (plate no. 3), a delicate pastel portrait, shows a movement away from a generalized interest in peasant types and toward the psychological.

Olga Boznańska (1865–1940) embraced impressionism intellectually as well as technically. Her *Woman in a Blue Dress* (plate no. 8) is striking not only for its coloristic composition but also for the confrontational mien of its sitter, which gives the piece a wholly contemporary tone. Vlastimil Hoffman (1881–1970) known primarily for his devotional works, painted *Saint Christopher and the Child Jesus* (plate no. 22) for the Kosciuszko Foundation toward the end of his long career. The influence of Jacek Malczewski and the great colorist Jan Stanisławski can be seen.

Although Władysław Teodor Benda (1873–1948) is known primarily for his work from this century, he remained stylistically aligned with the romantic currents of the nineteenth century. A great friend and supporter of Mizwa, Benda used his many talents to promote the Foundation during its early years. Acting as artist-in-residence,

Benda provided original artwork for numerous Foundation publications of which *Before the Storm* (plate no. 5), *Polish Dance, Krakowiak* (plate no. 6) and *Highlander Dance* (plate no. 7) are only but a sampling.

A work with a less direct but nonetheless interesting connection with the Foundation is *Portrait of Felicija Stachowicz-Grek* (plate no. 1) by Alexander Augustynowicz (1865–1944). The painting came from the estate of the American violinist Robert Perutz, a friend of the Foundation, and archival research has only recently led to the identification of the sitter as his mother-in-law, and thus also prompted a change of title from the earlier *Portrait of a Lady*. Tadeusz Styka (1889–1954), son of the Polish historical painter Jan Styka, enjoyed great popularity in this country as a society portraitist. His *Portrait of Anne Koons Parrish* (plate no. 40) portrays the sister of Mary Koons, an early benefactor of the Kosciuszko Foundation and its scholarship programs. The artist Mizwa chose to paint his own portrait was a man whose aesthetic loyalties were to the formal traditions of the past. Bernard Frydrysiak (1908–1970) was an original member of the Warsaw Brotherhood of Saint Luke, a group highly influenced by the Dutch masters. The *Portrait of Prof. Stephen P. Mizwa* (plate no. 16) is a somber rendering of the sitter in academic garb. Mizwa, a humble man not inclined to call attention to himself, here bears the distinctions of his scholarly career.

The interwar period brought a relaxation and something of a retreat from nationalistic themes. Artists allowed themselves the luxury of pursuing formal exploration from purely aesthetic motives. Polish colorists seemed especially liberated. Marcin Samlicki (1878–1945) painted familiar scenes from the Polish countryside, but with a very individual palette as in *The Old Wooden Church* (plate no. 36) and *The Pink Road* (plate no. 37). Gustaw Gwozdecki (1880–1935) was a controversial artist who found acceptance in Paris and New York more readily than at home. His characteristically active line is

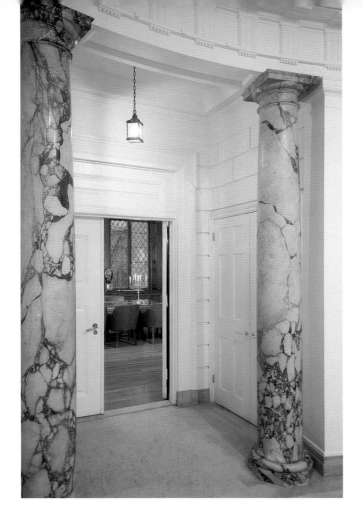

*Entrance to
Reception Room
Rotunda Level*

are not discussed in this catalog, a partial listing may be found in the appendix.

In the 1970s the Foundation's Rotunda was fitted with new lighting and has since been used almost exclusively as an exhibition space for contemporary art. During this period a number of travelling exhibits, particularly of documentary photographs was conceived by the Foundation. In 1975 and 1976 the physical condition of the collection was evaluated by Prof. Józef Flik, chief conservator of painting at the Nicholas Copernicus University in Toruń, who undertook the conservation of over forty paintings. Since the seventies the Foundation has been fortunate to host some of Poland's most promising artists under the auspices of the exchange program. As grantees of the Foundation, many have left behind artwork that has further enhanced the collection.

More recently, the Foundation has supported a number of important exhibitions of Polish art in the United States. The Polish Masters collection travelled in 1984 to the Hall of Honor, Hotel de Ville, in Montreal, in 1992 to the Albright-Knox Gallery in Buffalo, New York and the American International College in Springfield, Massachusetts, and in 1994 to the Museum of Fine Arts in St. Petersburg, Florida. In 1993 the Foundation helped in the acquisition of a collection of contemporary Polish graphic works by the Museum of Modern Art in New York.

In 1993 the Kosciuszko Foundation House underwent a comprehensive renovation under the direction of architect William Hess. Extra exhibition space was created for public access on the lower level. The Palladian balustrade was extended to the lower level with a semicircular stairway that leads to a marble faced foyer— the entrance to the Foundation's bookstore.

To know the art of another culture is to become acquainted with its essential spirit. The collection of the Kosciuszko Foundation offers viewers a unique perspective on Poland, its history, and its people.

Elizabeth Koszarski-Skrabonja
New York, 1995

evident in *French Riviera* (plate no. 19) and in his beautifully rendered drawings (plates nos. 20, 21), part of a suite of forty in the Foundation's collection.

A LEGACY CONTINUES

The gallery of Polish Masters, with its focus on nineteenth century works, does not represent the full extent of the Foundation's holdings. Polish artwork is displayed throughout the Foundation House's five levels. There is a sizeable collection of works on paper: drawings, lithographs, etchings, posters, woodcuts, maps, watercolors, and photographs. There is also sculpture, paintings, and tapestries by contemporary masters. These works have been donated by friends of the Foundation or by visiting artists. A special archive has recently been created to preserve and make available for study those works not displayed.

Other areas of strength in the collection include the art of the interwar period, eighteenth and nineteenth century graphic works, an impressive collection of period photographs chronicling the experience of Poles in America, and a small but important collection of postwar Polish painting. Although these works

ALEKSANDER AUGUSTYNOWICZ

born February 7, 1865, in Iskrzynia near Krosno
died August 23, 1944, in Warsaw

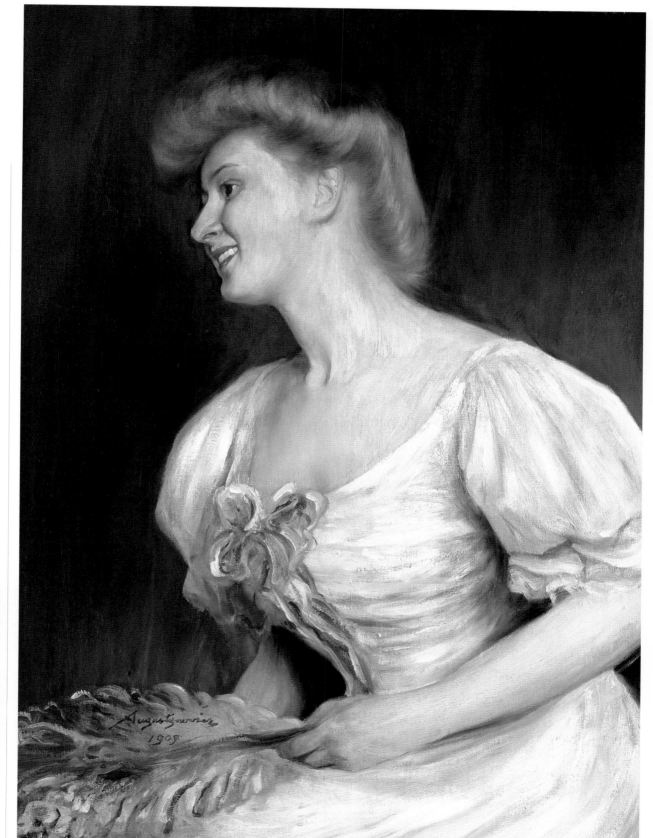

1

Portrait of Felicja Stachowicz-Grek

Oil on canvas
39 x 30 inches
Signed: Augustynowicz,
1909

Donated from the Estate of Robert Perutz.

The sitter, only recently identified from photographs in the Foundation's archive, is a renowned actress of the Lwów stage

Augustynowicz studied at the Kraków School of Fine Arts under Feliks Szynalewski, Władysław Łuszczkiewicz, and Jan Matejko. After a stay in Munich in 1888, he toured Italy and Hungary. He lived in Lwów from 1890 to 1914, then in Zakopane to 1921, and thereafter in Poznań. Augustynowicz was a member of the Lwów Association of Polish Artists, the Warsaw Club of Polish Watercolorists, and the "Zachęta" Society of the Fine Arts. His works were exhibited in Kraków, Lwów, Poznań, and Warsaw, as well as in Berlin, Vienna, London, and Munich. Although he painted a number of landscapes and genre scenes, Augustynowicz is known primarily as a portraitist. In 1937, he was awarded the Gold Cross of Merit. Augustynowicz died tragically during the Warsaw Uprising.

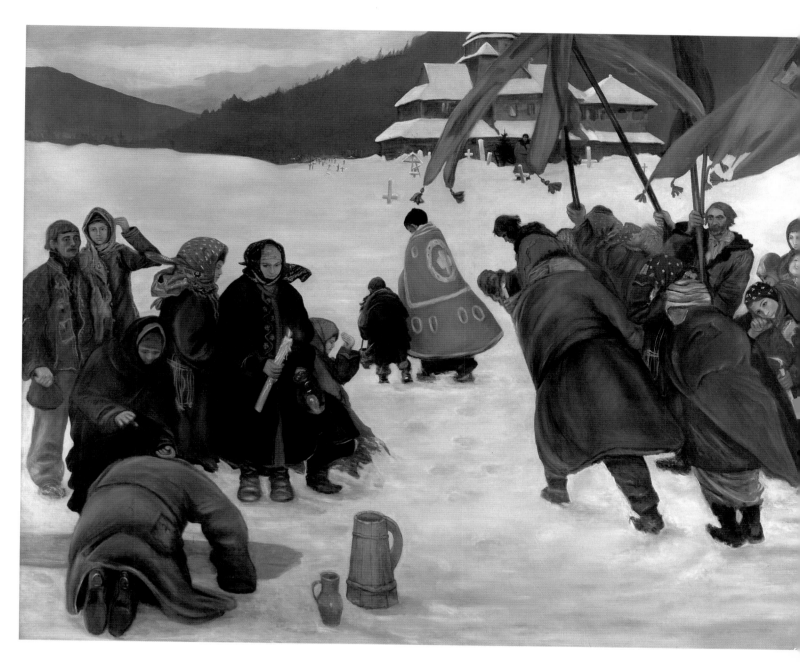

The Blessing of the Waters among the Hutzuls

Oil on canvas
101 X 130 inches

Unsigned, undated

After finishing high school in Lwów, Axentowicz spent four years (1878–1882) studying art at the Munich Academy of Fine Arts under Gabriel Hackel, Alexander Wagner, and Gyul Benczur. His advanced training was acquired in the studio of Carolus-Duran during a residence in Paris (1892–1895). While in that city he worked as an illustrator for *Le monde illustré* and further augmented his income with a series of avidly sought copies of works by such masters as Botticelli, Titian, Velázquez, and Correggio. He also traveled frequently to London to fulfill portrait commissions. In 1890 alone, for example, he painted twelve portraits.

In London, Axentowicz took an interest in eighteenth-century English painters (George Romney and Thomas Gainsborough, among others), contemporary American artists such as John Singer Sargent and James A. Whistler,

The Hutzuls are highlanders (górale) of southeastern Poland whose folkways were attractive to numerous Polish artists. Depicted in this monumental composition is a rite associated with the Feast of the Epiphany (January 6).

and the Pre-Raphaelites. In Parisian artistic and intellectual circles, Polish as well as French, he was highly acclaimed as a portrait painter. His subjects included the actress Sarah Bernhardt, Henrietta Fouquier (renowned as one of the great beauties of her time), Władysław Czartoryski, and Władysław Osławski. The Osławski portrait earned him membership in the Société nationale des beaux arts in 1890. Axentowicz advanced the art of portraiture primarily through his pastel technique, as is most evident in his delicate portraits of women, with their symbolist and Secessionist elements.

His cosmopolitanism notwithstanding, Axentowicz took a keen interest in the folklife of the eastern Małopolska (Little Poland) region. The spectacle of secular and religious holidays there inspired in him the desire to transfer the decorativeness of folk art—of costume and iconography, for example—to "professional" easel painting. Compositions in this vein include *The Blessing of the Waters, Easter Dinner, Procession, Kolomyjka,* and

🖻 3

Spring and Winter

Pastel on cardboard
20 x 27 inches
Signed lower right
ca. 1910

Donated by Drs. Jan and Irene Dobrowolski, 1994.

Oberek, the latter two inspired by popular dances. Axentowicz's legacy includes, in addition to the oils and pastels, watercolors and lithographs.

In 1895, Axentowicz moved to Kraków, where until 1934 he was professor in the School of Fine Arts (after 1900 the Academy of Fine Arts), which had been reorganized by the artist Julian Fałat. He was twice elected rector of the institution. In 1898 he founded a school of painting for women. Axentowicz was also one of the founders of the "Sztuka" Society of Polish Artists and took part in virtually all its domestic and foreign exhibitions. A member of the Vienna Secession, he contributed to its journal *Ver Sacrum*. In 1904 he spent a few months in Saint Louis, Missouri, as one of the organizers of the Polish section of the International Exposition. He participated also in exhibitions in Dresden, Vienna (the IXth International), Munich (1905) and Rome (1911). He served as director of the Polish section of the International Exposition in Venice in 1914 and had several one-man shows in Poland (Kraków, 1923 and 1927; Łódź and Warsaw, 1938). A posthumous retrospective was held at the Society of Fine Arts in Kraków in 1938 and the following year in Lwów. His paintings can be found in almost all public collections in Poland and in numerous private ones there and abroad.

BIBLIOGRAPHY

Słownik Artystów Polskich (entry by Janusz Derwojed), 1:49–52 (Wrocław, 1971).

WŁADYSŁAW BAKAŁOWICZ

born May 28, 1833, in Chrzanów
died November 15, 1903, in Paris

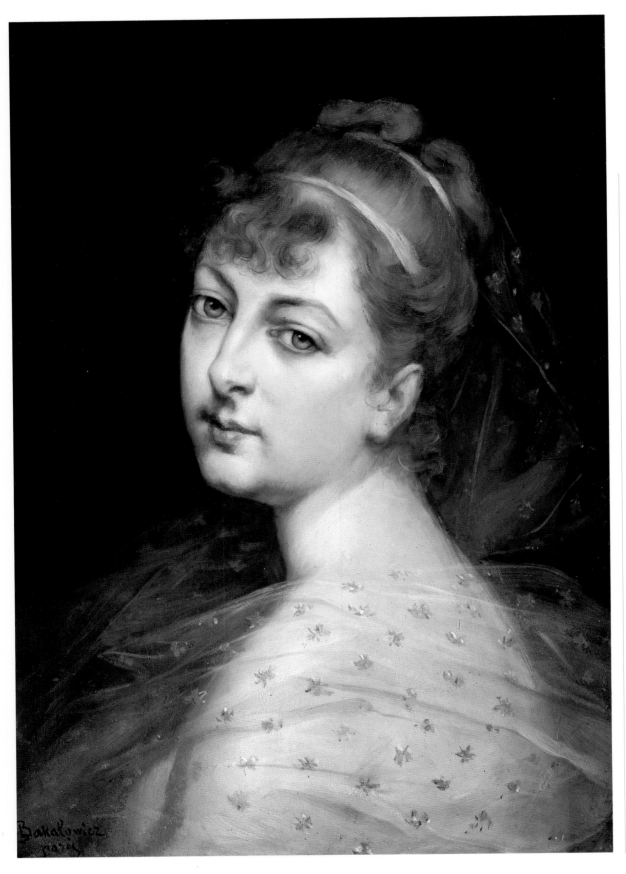

□ 4

Portrait of a Lady

Oil on wood
12 x 9 inches
Signed: Bakałowicz
Paris
undated

*Exhib.: Polish Painters
1850–1950, Montreal, 1984
(repr.). Poland's Artistic
Heritage: Selected
Paintings from the
Kosciuszko Foundation,
Albright-Knox Gallery,
Buffalo, New York, 1992.
Selected Paintings from the
Kosciuszko Foundation
Collection, Museum of Fine
Arts, St. Petersburg,
Florida, 1994.*

Bakałowicz studied at the Warsaw School of Fine Arts from 1849 to 1854. In 1863 he left for France; he settled permanently in Paris and became a French citizen. The artist was married to the actress Wiktoryna Szymanowska. Their son Stefan was also a painter.

Early in his career Bakałowicz painted portraits, genre scenes, and historical canvases on Polish themes. These earlier works include *King Zygmunt August and Barbara Radziwill, Prince Karol Radziwill Receiving a Delegation of Bar Confederates,* and *Bazaar Outside the Iron Gates.* His most representative works, however, are genre scenes drawn from sixteenth- and seventeenth-century French history, especially the court of Henry III Valois. Executed in oil, pastel, or watercolor, these small-scale compositions reveal Bakałowicz's fondness for the realistic rendering of details of costume and interior. Sources for the artist's treatments can be found in the Dutch masters and in the contemporary works of Ernest Meissonier, influences that are particularly evident, for example, in *Lord Buckingham at the Court of Louis XIII,* and *Episode from St. Bartholomewis Night.*

Bakałowicz's work was well received by the French and internationally, and he exhibited at the Paris salons (1865, 1883), in such provincial cities as Lyons, Bordeaux, Reims, Rouen, Nice, and Pau, and also in London, Brussels, Berlin, Vienna, and New York. Two full-length portraits were shown at the Loan Exhibition of Polish Paintings at the Metropolitan Museum of Art in 1944.

Bakałowicz remained in constant contact with Poland and participated in exhibitions at the Warsaw "Zachęta" Society of Fine Arts, the Kraków Society of Fine Arts, and the Warsaw salon of Alexander Krywult, where posthumous exhibitions were mounted in 1904 and 1906.

The artist's paintings are in museum collections in Warsaw, Kraków, and Radom, as well as in many private collections in Poland and abroad.

Bakałowicz frequently signed his works "LADISLAUS" or "L."

BIBLIOGRAPHY

Słownik Artystów Polskich (entry by Janusz Derwojed), 1:73–74 (Wrocław, 1971).

❧ WŁADYSŁAW TEODOR BENDA

born January 15, 1873, in Poznań
died in 1948 in New York

▣ 5

Before the Storm

Oil on canvas
64 x 37 inches
Signed: W. T. Benda
ca. 1915

*Donated by Mr. & Mrs.
John J. Sokolowski,1952
Exhib.: Polish Painters
1850–1950, Montreal, 1984
(repr.). Poland's Artistic
Heritage: Selected
Paintings from the
Kosciuszko Foundation,
Albright-Knox Gallery,
Buffalo, New York, 1992.
American International
College, Springfield,
Massachusetts, 1992.
Selected Paintings from the
Kosciuszko Foundation
Collection, Museum of Fine
Arts, St. Petersburg,
Florida, 1994.*

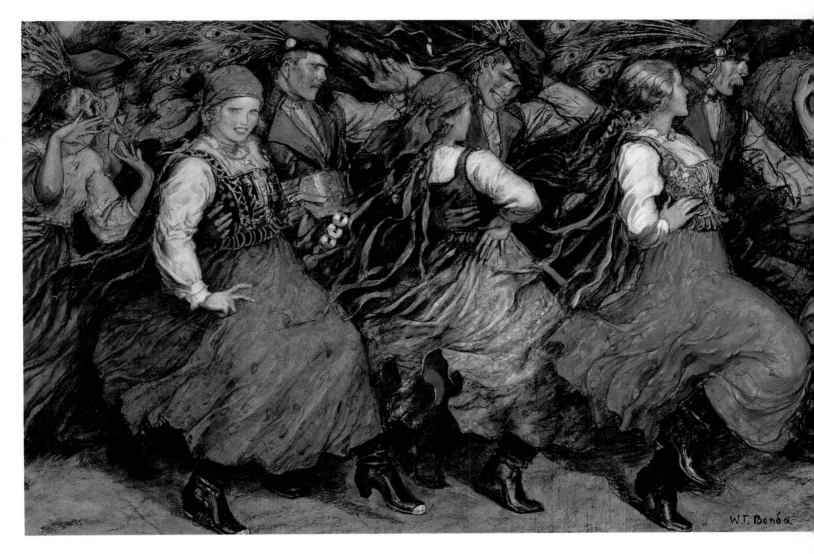

🖾 6

Polish Dance, Krakowiak

Pastel and colored crayon on cardboard
25 x 40 inches
Signed: W. T. Benda
ca. 1930

Benda was the son of musician Jan Szymon Benda and a nephew of the actress Helena Modrzejewska (known as Helena Modjeska in the United States). From 1892 to 1894 he studied at the Kraków School of Fine Arts under Władysław Łuszczkiewicz, Florian Cynk, and Izydor Jabłoński. He continued his studies in Vienna, San Francisco, and New York. In 1899 he settled permanently in the United States, first in Los Angeles, where he opened a school of painting, and then, around 1911, in New York City.

Benda began his career as a set and costume designer, thanks to the support of Helena Modrzejewska. He designed her production of Shakespeare's *Antony and Cleopatra* in Los Angeles. In New York he was known for his portraits of women. Unfortunately, many of his paintings were lost in a fire at Alliance College in Cambridge Springs, Pennsylvania, in January 1931.

Several of his works were executed expressly for the Kosciuszko Foundation (among them portraits of Queen Jadwiga of Poland and General Kościuszko), and he acted, in effect, as its "artist-in-residence" from the time of the opening of the Foundation House until his death. His *Krakowiak,*

*Donated by the artist.
Exhib.: Polish Painters 1850–1950, Montreal, 1984 (repr.). Poland's Artistic Heritage: Selected Paintings from the Kosciuszko Foundation, Albright-Knox Gallery, Buffalo, New York, 1992. American International College, Springfield, Massachusetts, 1992. Selected Paintings from the Kosciuszko Foundation Collection, Museum of Fine Arts, St. Petersburg, Florida, 1994.*

in this collection, initially brought him to the attention of Professor Mizwa of the Foundation, and thus began many years of friendship and collaboration.

The artist's *Reverend Skapka* is in the Polish Museum of Chicago. He painted a gallery of Polish military figures under the collective title *Polish Heroes of the Revolutionary War* (completed ca. 1943).

Benda was a celebrated illustrator whose work appeared in popular magazines, such as *Century*, *Scribners*, and *Cosmopolitan*, as well as in books, such as H. W. Mabie's *Parables of Life* (New York, 1905). His media included also murals and masks. He outlined his mask-making technique in *Masks* (New York, 1944), which enjoyed wide use as a textbook on the subject. Benda was a member of the Society of Illustrators, the Society of Mural Painters, and the Architectural League of America in New York.

BIBLIOGRAPHY

Słownik Artystów Polskich (entry by Andrzej Ryszkiewicz), 1:128–129 (Wrocław, 1971).

7

Highlander Dance

Pastel on cardboard
25 x 30 inches
Signed: W. T. Benda
ca. 1940

Donated by the artist. Exhib.: Poland's Artistic Heritage: Selected Paintings from the Kosciuszko Foundation, Albright-Knox Gallery, Buffalo, New York, 1992. Selected Paintings from the Kosciuszko Foundation Collection, Museum of Fine Arts, St. Petersburg, Florida, 1994.

OLGA BOZNAŃSKA

born April 15, 1865, in Kraków
died October 26, 1940, in Paris

8

**Woman in a
Blue Dress**

Oil on cardboard
38 x 28 inches
Signed:
Olga Boznańska
ca. 1918

*Donated by Mr. & Mrs.
Alexander R. Koproski,
1977.
Exhib.:Polish Painters
1859–1950. Montreal, 1984
(repr.). Poland's Artistic
Heritage: Selected
Paintings from the
Kosciuszko Foundation,
Albright-Knox Gallery,
Buffalo, New York, 1992.
American International
College, Springfield,
Massachusetts, 1992.
Selected Paintings from the
Kosciuszko Foundation
Collection, Museum of Fine
Arts, St. Petersburg,
Florida, 1994.*

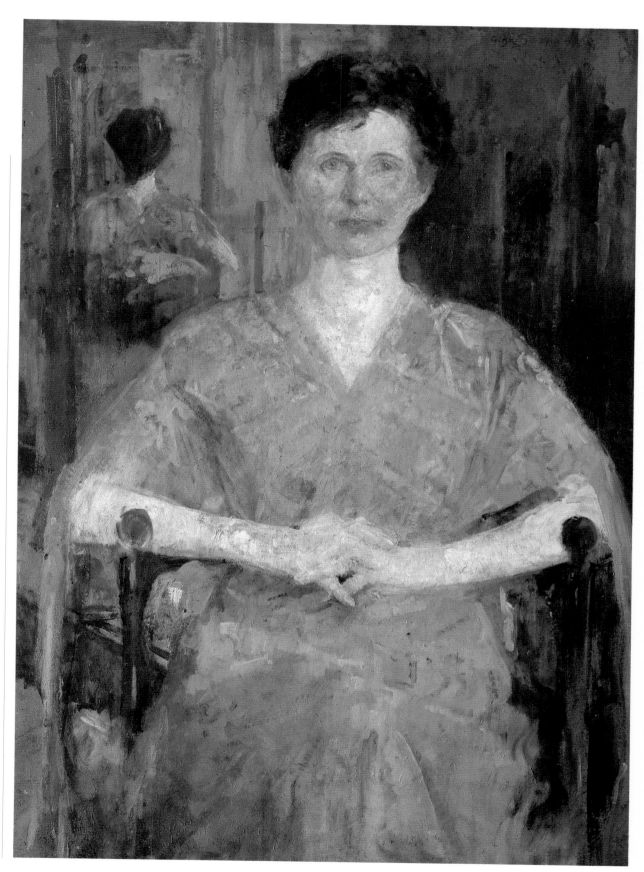

Together with her sister Izabela, Olga Boznańska received her first lessons in drawing from her mother. Her subsequent teachers were Józef Siedlecki and Kazimierz Pochwalski. She then studied painting with Hipolit Lipinski and from 1884 to 1886 attended the courses of A. Baraniecki in Kraków. Further studies were undertaken in Munich, initially in the private school run by Karl Kricheldorf and later under the tutelage of the modernist Wilhelm Dürr. Other Polish artists in Munich at the time, such as Józef Brandt, Alfred Wierusz-Kowalski, and Wacław Szymanowski, also took an interest in her development.

After three years of study in Munich Boznańska opened her own studio there. She befriended a number of Munich painters, among them Paul Nauen, whose portrait by her hangs in the National Museum in Warsaw. She remained in Munich until 1898, travelling occasionally to France, Switzerland, Vienna, and Berlin.

In 1895 the Berlin journal *Bazar* included Boznańska among the twelve best women painters in Europe. That same year she succeeded Theodor Hummel in his private school of painting in Munich, where she was highly regarded for her teaching. She was subsequently offered—but declined—the directorship of the women's section of the Academy of Fine Arts in Kraków. Boznańska debuted in Paris in 1896, at the salon of the Société nationale des beaux-arts. In 1904 she became a member of the society. In 1898 she moved permanently to Paris. Boznańska belonged to the "Sztuka" Society of Polish Artists, the Association of Polish Women Artists in Kraków, the International Society of Sculptors, Engravers and Painters, the Society of Polish Artists in Paris, and the Polish Literary-Artistic Society.

Boznańska began to exhibit early, both in Poland and elsewhere, and she participated in a number of international exhibitions. In her lifetime, however, she had only a single one-woman show in Poland, at the Kraków Society of the Friends of Art in 1931. Posthumous exhibitions were held at the Bibliothéque polonaise in Paris in 1945 and at the Society of Fine Arts in Kraków the following year. A comprehensive retrospective exhibition was mounted at the National Museum in Kraków in 1960.

Boznańska was the recipient of numerous artistic awards, including that of the Probusz Barczewski Foundation in 1908 and the Award for Art of the City of Warsaw in 1934. She was honored with the French Legion of Honor in 1912 and the Order of Polonia Restituta in 1938. In 1959 a plaque honoring her was placed at the site of Académie Colarossi in Paris (16, rue de la Grande Chaumière), where Boznańska had taught drawing. The artist is buried in the Polish cemetery of Montmorency near Paris.

Notwithstanding her popularity as a teacher and her wide success as an artist, Boznańska led an unusually modest and solitary life in Paris. In her final years she confined herself almost entirely to her studio.

Boznańska is esteemed primarily as a portraitist and secondarily as a painter of still lifes and landscapes. Although her work reveals the influence of James A. Whistler—particularly in the silvery coloring and the sketchy contours—and that of certain French postimpressionists, Boznańska developed an individual style. In her portraits she concentrated on capturing the psychology of the subject, but not by bringing him or her closer to the viewer in a realistic manner (for example, through a sharper modeling of the features). Instead, her effects were achieved through a subtle sinking of the silhouette or head into a background of similar tone. Muted hues, primarily cool, diaphanous greenish planes, a matte surface (usually cardboard without a ground) and a light brush stroke create the impression of a delicate screen suspended between the subject and the viewer. The effect does not detract from a sharp, expressive characterization of the face.

Boznańska's works can be found in museums in Poland (especially in the national museums in Kraków and Warsaw) as well as in Paris, Venice, and Prague, and in Polish and foreign private collections.

BIBLIOGRAPHY

Helena Blumówna, *Olga Boznańska 1865–1940: Materiały do monografii* (Warsaw, 1949); Helena Blumówna, *Olga Boznańska: Zarys zycia i twórczosci* (Kraków, 1964); *Słownik Artystów Polskich* (entry by Helena Blumówna), 1:221–225 (Wrocław, 1971); Helena Blumówna, *Olga Boznańska* (Warsaw, 1974).

JÓZEF BRANDT

born February 11, 1841, in Szczebrzeszyn
died June 12, 1915, in Radom

🖼 9

Light Cavalry Lisowczycy

Oil on canvas
42 x 35 inches
Signed: Józef
Brandtz Warszawy–
Monacium 1885

Donated by Mr. & Mrs. Stanley Kupiszewski, 1958. Exhib.: Polish Painters 1850–1950, Montreal, 1984 (repr.). Poland's Artistic Heritage: Selected Paintings from the Kosciuszko Foundation, Albright-Knox Gallery, Buffalo, New York, 1992. Selected Paintings from the Kosciuszko Foundation Collection, Museum of Fine Arts, St. Petersburg, Florida, 1994.

Depicted is a military display of the so-called Lisowczycy, the contingent of volunteer cavalry organized in the seventeenth century by Colonel Aleksander Lisowski. The archer's target, a turban, alludes to their encounters with the Turks in southeastern Poland.

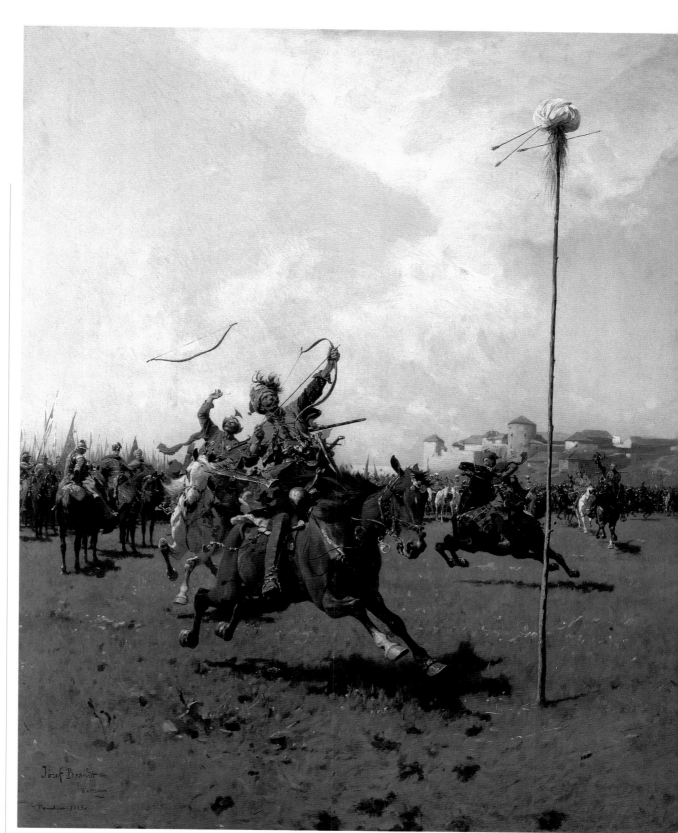

30

Brandt studied in Warsaw in the school of J. N. Leszczyński and at the Nobleman's Institute. In 1858 he left for Paris to study at the Ecole des ponts et chaussées but was persuaded by Juliusz Kossak to abandon engineering in favor of painting. Kossak and Henryk Rodakowski were his first teachers in Paris, and for a time he attended the studio of Léon Cogniet. He continued his study in Munich in 1862, chiefly under Franz Adam, Theodor Horschelt, and Karl von Piloty. From 1866, except for summer vacations on the family estate near Radom, he remained in Munich, where his studio became a gathering place for expatriate Polish artists. One of the foremost Polish artists of the so-called Munich school, he was a rapid success both financially and artistically, and he attracted many students and imitators. From 1875 he ran an informal school for young painters, mostly Poles. In 1875 Brandt was elected to the Berlin Academy, in 1878 to the Munich Academy, and in 1900 to the Academy of Fine Arts in Prague.

Brandt's principal subjects were scenes of the seventeenth-century Cossack wars and the Tatar and Swedish invasions of Poland. His were imaginative treatments, and not representations of precisely defined historical moments, though he took great pains to accurately depict costumes, weapons, harnesses, and musical instruments, models for all of which filled his studio. His favorite motif was the plains horse in motion, galloping or attacking, together with the colorful figure of the rider—Cossack, Tatar, Lisowczycy (Polish light cavalry of the period)—the two caught up in the frenzy of combat. Both the military and the bazaar and hunt scenes show an element of eastern exoticism.

Brandt attracted attention early for bravura compositions that frequently broke with academic conventions. At the 1869 Universal Art Exhibition in Munich he won the Gold Medal, First Class, for *Strojnowski Presenting Captured Horses to Prince Leopold.* In 1873 he received the Order of Franz Josef for his *Relief of Vienna,* and in 1891 the Grand Gold Medal at the International Art Exhibition in Berlin. In 1893 he was nominated a Commander of the Spanish Order of Isabella the Catholic, and in 1898 he won the Bavarian Order of Maximilian.

Brandt's canvases hang in nearly all Polish museums, and he is represented also in museums and private collections in America and Europe. The first one-man exhibition was held in 1887 at the Warsaw "Zachęta" Society of Fine Arts, which was also the venue for a posthumous retrospective in 1926. Two large showings of his paintings were organized in the Regional Museum of Radom in 1965 and 1985.

BIBLIOGRAPHY

I. Derwojed, *Josef Brandt* (Warsaw, 1969); *Słownik Artystów Polskich* (entry by Janusz Derwojed), 1: 226–228 (Wrocław, 1971).

JAN CHEŁMIŃSKI

born January 27, 1851, in Brzustów near Opoczno
died November 1, 1925, in New York

10

His Last Vision

Oil on canvas
32 x 22 inches
Signed: Jan Chełmiński
ca. 1904

*Donated by the artist's
widow, Mme. Jan de
Chełmiński, née Knoedler,
1950.*

This work is a version of
Cheveau-léger de la Garde
impériale, *one of forty-eight
compositions of the artist
reproduced in* L'Armée du
duché de Varsovie
(Paris, 1913).

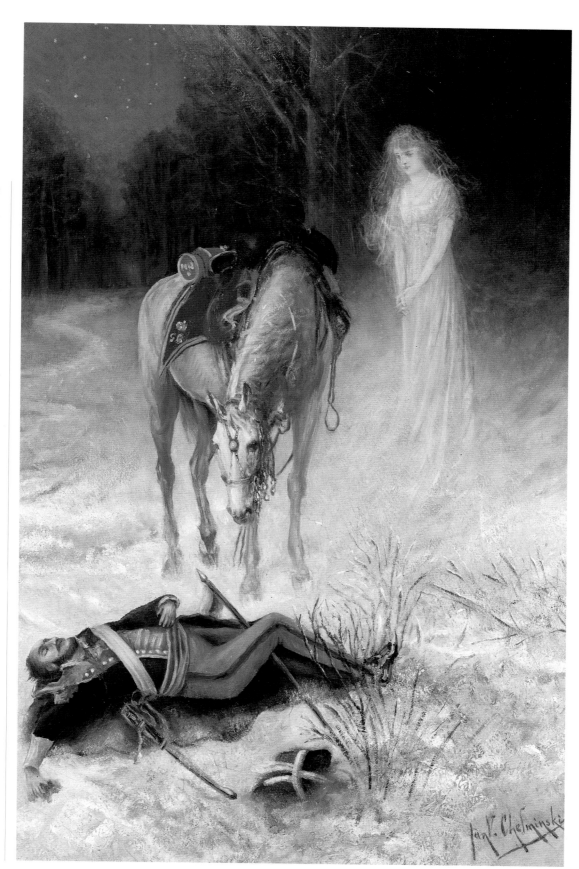

32

Chełmiński began his training with two years (1866–1868) at the Warsaw Drawing School and independent study with Juliusz Kossak. In 1873 he left for Munich, where he worked with Alexander Strähuber and Alexander Wagner, Józef Brandt (1875), and Franz Adam (1876). During this period he traveled extensively in Europe and the United States, with lengthy stays in New York, London, and Paris. Ten years before his death he returned to New York.

Chełmiński exhibited sporadically in Poland beginning in 1873, and from 1875 in Munich, Berlin, Vienna, London, and Paris. His first works were copies of watercolors by Juliusz Kossak. Under the influence of Kossak and of Józef Brandt and Maksymilian Gierymski, he painted hunting scenes and eighteenth-century genre pictures that won him rapid popularity. With the support of Franz Adam he gained entry to the court of Bavaria, where he painted portraits of, among others, Princess Teresa, Prince Regent Leopold, and Prince Emanuel. King Louis bought his *The Hunt Par Force*. In England and America Chełmiński painted sport and genre scenes in the spirit of English painting. These proved very popular, their renown growing especially after Chełmiński married the sister of Roland F. Knoedler, the well-known antiquarian. While in America Chełmiński became friendly with Theodore Roosevelt and illustrated his hunting stories, which appeared in Century Magazine in 1885.

Chełmiński's financial success allowed him to collect weapons, especially of the Napoleonic period, and to devote time to serious research of military history. His first work reflecting this interest was *Battle of Yorktown*, a composition in which both George Washington and Tadeusz Kościuszko appear. The picture is now in a private collection in the United States.

During a short stay in Saint Petersburg in 1898 Chełmiński worked at the imperial court. A large collection of his battle scenes from the Napoleonic era was exhibited in 1904 at the Galerie des artistes modernes in Paris. Among the works shown were *Polish Uhlan from 1812, Portrait of Prince Józef Poniatowski*, and *Review of the Troops of the Duchy of Warsaw by Tsar Alexander I*. That same year forty-eight oils devoted to the army of the Duchy of Warsaw were exhibited in Paris. They were also shown in Warsaw in 1907 at the salon of Stefan Kulikowski. Knoedler bought the entire cycle in 1913 and offered it to the Municipal Museum of Warsaw. The paintings are now in the Army Museum in Warsaw. In 1913 these works, together with a text by Commandant A. Malibran, were published in an album entitled *L'Armée du duché de Varsovie* (Paris: J. Leroy et fils). Chełmiński's battle scenes, though perhaps less dynamic than the best work in this genre, demonstrate superior craft and provide valuable documentation of the uniforms and weaponry of the period, all depicted after the manner, for example, of Jean Louis Ernest Meissonier.

Chełmiński's major one-man exhibitions were in London (1892, Continental Gallery), Warsaw (1894, the salon of Aleksander Krywułit), and Paris (1901, Galerie Chaine, Galerie Somouson).

The artist's works are in Polish museums, including those in Warsaw and Radom, and in private collections in England and the United States.

BIBLIOGRAPHY

Słownik Artystów Polskich (entry by Hanna Bartnicka-Gorska), 1:312–314 (Wrocław, 1971); Jadwiga Daniec, "Jan Chełmiński," *Polish Review* (1979).

✲ JÓZEF MARIAN CHEŁMOŃSKI

born November 7, 1849, in Boczki near Lowicz
died April 7, 1914, in Kuklowka near Grodzisk Mazowiecki

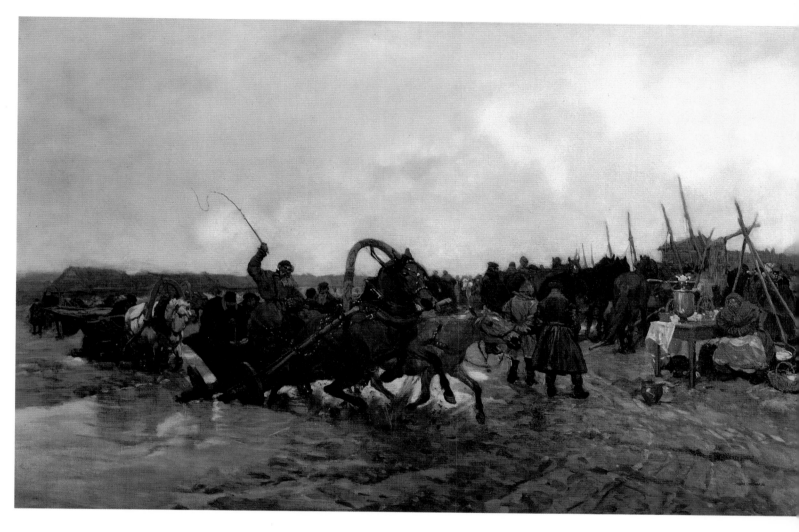

📷 11

Country Fair

Oil on canvas
23 x 27 inches
Signed: Józef
Chełmoński
ca. 1893

From 1867 to 1871 Chełmoński studied at the Warsaw Drawing School and in the private studio of Wojciech Gerson, who exerted a strong influence on his early work. From 1871 to 1874 he lived in Munich, where for several months he studied at the Munich Academy with Herman Anschütz and Alexander Strähuber. Of greater importance, however, was his association with the circle of Munich-based Polish artists, including, Józef Brandt and Maksymilian Gierymski.

Return trips to Poland in 1872 and 1874 provided him the opportunity to visit Podolia and the Ukraine. The seemingly limitless expanse of the eastern Polish border regions left an indelible impression, evident in the artist's later work, which, together with that of the brothers Aleksander and Maksymilian Gierymski, epitomizes Polish landscape painting of the period.

In 1875, with the help of the sculptor Cyprian Godebski, Chełmoński went to Paris, visiting Vienna and Italy en route. His stay in the French capital, where he very quickly began exhibiting in official salons, brought him considerable renown. In 1882, for example, he drew praise for his *Cossack Encampment*, and in 1889 he won the Grand Prix at the Universal Exposition.

In 1878 the Parisian art dealer A. Goupil contracted with the artist for first option on the purchase of all his paintings; many of the

Donated by Miss Mary R. Koons in memory of her sisters Anne Koons Parrish and Mrs. John Bonin, 1968 Exhib.: Polish Painters 1850–1950, Montreal, 1984 (repr.). Poland's Artistic Heritage: Selected Paintings from the Kosciuszko Foundation, Albright-Knox Gallery, Buffalo, New York, 1992. American International College, Springfield, Massachusetts, 1992. Selected Paintings from the Kosciuszko Foundation Collection, Museum of Fine Arts, St. Petersburg, Florida, 1994.

34

works of this period thus came into the possession of English and American collectors. These canvases typically feature the motif for which Chełmoński is best known—a team of four horses galloping through the snow. Unfortunately, the repetitions of the motif worked from memory and on commission were often hastily executed and considerably diminished in quality relative to the originals.

Chełmoński also worked as a graphic artist and illustrator. A collection of his mono-lithographs was published in the *Portfolio of Polish Graphic Artists* (Kraków, 1903). From 1884 to 1892 he was affiliated with the Parisian magazine *Le monde illustré*.

He returned permanently to Poland in 1887 and settled in the village of Kuklowka near the town of Grodzisk Mazowiecki, making occasional trips to Lithuania, the Ukraine, and Polesie. His landscapes and genre paintings from this period demonstrate a marked tranquility of form. Now melancholic and reflective, the landscapes express a deepened affection for the lowlands of his native region. A frequently recurring element is a flock of birds, as in *Passage of Storks and Quails*, or a stray animal.

Chełmoński's works were first exhibited in Poland at the Warsaw "Zachęta" Society of Fine Arts (1869), the salon of Aleksander Krywult, and the Kraków Society of Fine Arts (1871). Many Polish exhibitions followed. Showings abroad included Berlin (1891), San Francisco (1894), Vienna (1898), Chicago (1903), and Düsseldorf (1904). One-man exhibitions were held in Warsaw (1890, 1907, 1917, 1924, 1927), Kraków (1907), Lwów (1907), and Lowicz (1936).

In recognition of his service to Polish art he was elected honorary president of the "Sztuka" Society of Polish Artists in 1897, an honorary member of the Society of the Friends of Art in 1904, and an honorary member of the "Zachęta" Society of Fine Arts in Warsaw in 1907. Chełmoński's sizeable legacy—oil paintings, drawings, sketch books—resides mainly in Polish museums (including fifty-three of his paintings in the National Museum in Warsaw), and in private collections in Poland, Germany, England,and America.

BIBLIOGRAPHY

Jan Wegner, ed., *Józef Chełmoński in the Light of Correspondence* (Wrocław, 1953); *Słownik Artystów Polskich* (entry by Hanna Górska-Bartnicka), 1:314–316 (Wrocław, 1971); Maciej Maslowski, *The Artistic Biography of Józef Chełmoński*, 2d ed. (Warsaw, 1973); Maciej Maslowski, *Józef Chełmoński* (Warsaw, 1973); Alfred Ligocki, *Józef Chełmoński* (Warsaw, 1983).

WŁADYSŁAW CZACHÓRSKI

born September 22, 1850, in Lublin
died January 1, 1911, in Munich

12

Young Lady at the Fireplace

Oil on canvas
21 x 32 inches
Signed: Czachórski,
1882

*Donated by Dr. Walter M.
Golaski in memory of his
wife, Helene Dolores
Golaski, 1968
Exhib.: Polish Painters
1850–1950, Montreal, 1984
(repr.). Poland's Artistic
Heritage: Selected
Paintings from the
Kosciuszko Foundation,
Albright-Knox Gallery,
Buffalo, New York, 1992.
American International
College, Springfield,
Massachusetts, 1992.
Selected Paintings from the
Kosciuszko Foundation
Collection, Museum of Fine
Arts, St. Petersburg, Florida,
1994.*

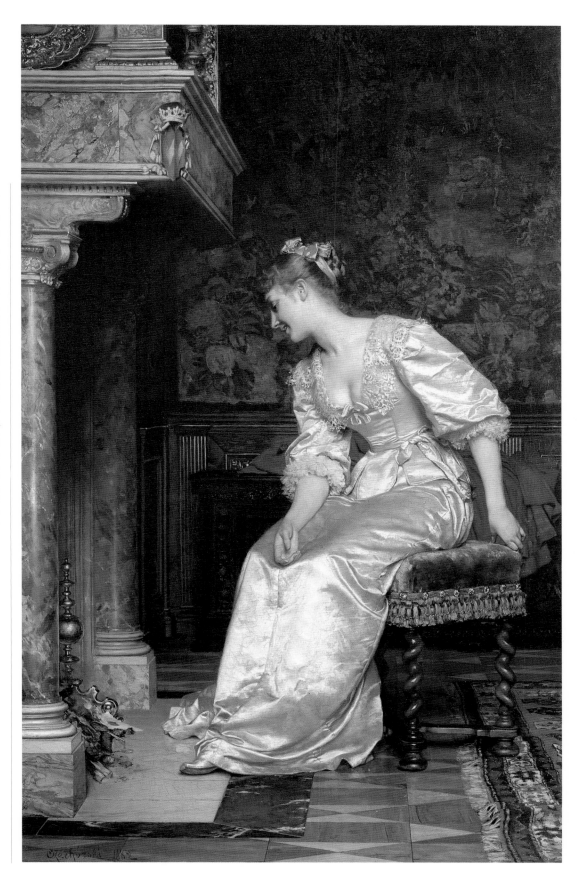

Czachórski began his studies with Rafał Hadziewicz at the Warsaw Drawing School in 1866. After a year at the Dresden Academy, he spent five years (1869–1873) at the Munich Academy studying with Hermann Anschütz, Alexander Wagner, and Karl von Piloty. Upon graduation, he received the Grand Silver Medal (*magna cum laude*). He traveled often to France, Italy, and Poland, but in 1879 he settled permanently in Munich. He was a member of the Berlin Academy, an honorary professor of the Munich Academy, and an organizer and jurist of international exhibitions. In 1893 he was awarded the Bavarian Order of Saint Michael. He participated in many exhibitions in Poland —in Warsaw, Kraków, Lwów, and Łódź. A posthumous showing was held at the Warsaw "Zachęta" Society of Fine Arts in 1911.

Czachórski painted portraits, still lifes, and Shakespearean scenes, such as *Juliette's Funeral* (1873), *Hamlet* (1873), and especially *Hamlet Receiving the Players* (1875), widely recognized as his greatest work. The hallmark of Czachórski's style, however, and the basis of his fame, are his images of beautiful young women in rich interiors, painted with great realism. He has long been regarded a master of rendering fabrics, jewelry, and other details to create an atmosphere of luxury and elegance.

His paintings are found in all the larger museums of Poland, in foreign museums, for example in Lwów and Bremen, and in private collections in Poland, Germany, England, and the United States.

BIBLIOGRAPHY

Słownik Artystów Polskich
(entry by Aleksandra
Melbechowska-Luty),
1:382–384 (Wrocław, 1971).

BOLESŁAW JAN CZEDEKOWSKI

born February 22, 1885, in Wojnilów in Podolia
died July 8, 1969, in Vienna

13

**Kościuszko
at West Point**

Oil on canvas
72 x 60 inches
Signed: Czedekowski,
B. 1947

*Donated by the artist, 1947.
Exhib.: Selected Paintings
from the Kosciuszko
Foundation Collection,
Museum of Fine Arts, St.
Petersburg, Florida, 1994.*

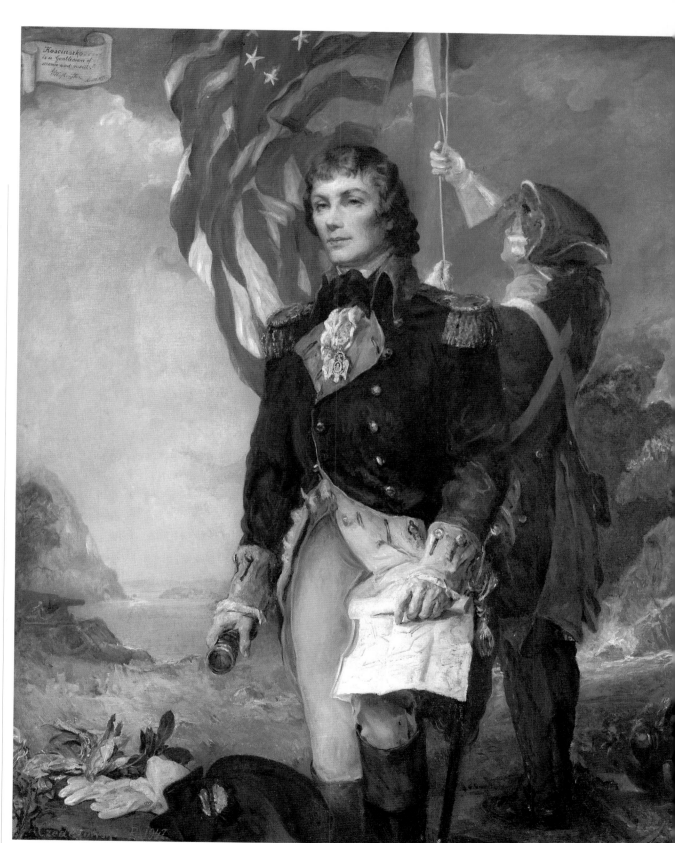

After high school in Stanislawów, Czedekowski studied art in Vienna from 1903 to 1911; his teachers were Rudolf Bacher, Heinrich von Angeli, and Kazimierz Pochwalski. He spent three years in the United States (1919–1922) before moving to Paris. During his long residence in France he often made return visits to the United States, where he settled after World War II.

Czedekowski exhibited frequently in such Parisian salons as the Société des artistes francais, Salon des indépendants, and Galerie Knoedler. He also sent paintings for exhibit at such prominent Polish institutions as the "Zachęta" Society of Fine Arts in Warsaw and the Society of the Friends of Fine Arts in Kraków.

Czedekowski's reputation rests principally on his portraits. Even during his early studies in Vienna, he painted the portraits of members of the imperial family and prominent figures at court and among the aristocracy. In Paris and America he won great favor as a society portraitist. Although realistic, his portraits tended to idealize the subject (a refined pose and dress and accessories emphasizing social class). Among the prominent who sat for him were Marshal Ferdinand Foch, the Polish president Ignacy Moscicki, and August Cardinal Hlond of Poland. In 1947 he was commissioned by the Kosciuszko Foundation for a portrait of Tadeusz Kościuszko in the uniform of the American Continental army. For the ten years following, Czedekowski lived and worked in the United States, exhibiting in Georgetown, Philadelphia, Alexandria, Houston, Charleston, and Richmond. In 1957 he returned to Europe, settling in Vienna. There his subjects included members of various noble families, and he enjoyed two major retrospective exhibitions, in 1964 at the Palais Palffy in Vienna and in 1965 at the Pałac Sztuki in Kraków.

Kościuszko at West Point 13 hangs permanently over the fireplace in the Gallery of Polish Masters at the Kosciuszko Foundation in New York City. It was painted expressly for the Foundation by Czedekowski at the request of its president, Professor Stephen P. Mizwa. Kościuszko is depicted life-size in the uniform of a brigadier-general of the American Continental army of the Revolution. He wears the order of the Society of the Cincinnati, of which he was a charter member. In the background is Fort Clinton, on the Hudson River. (The artist visited West Point several times to familiarize himself with the topography and with the subject's effects preserved there.) In the upper left-hand corner of the portrait is a shield bearing the words of George Washington: "Kościuszko is a man of science and merit."

The painting was unveiled in a ceremony at the Foundation's House on September 19, 1947. During the program a message was delivered from General Maxwell B. Taylor, superintendent of the United States Military Academy at West Point. It read in part:

On behalf of the Corps of Cadets and the Military Academy, I would like to send greetings to the members of the Kosciuszko Foundation upon the unveiling of this portrait of the man who has been so closely connected with the birth of our country and with the earliest history, of West Point. . . . Cadets have ever felt close to Kościuszko for his spirit. When Edgar Allen Poe left the Academy, without graduating, his first impulse took the form of a letter to the superintendent requesting aid in securing a commission in the Polish Army. In 1828, fifty years after Kościuszko had done his work at West Point, the cadets erected a monument to his memory paid for by contributions from their pay. The memory of this great man is forever woven into the tradition of West Point.

BIBLIOGRAPHY

Karl Strobl, *Bolesław Jan Czedekowski: The Artist and His Work*, (Vienna, 1959); Karl Strobl, *Bolesław Jan Czedekowski: Ein Künstlerleben* (Vienna, 1960); Hann Muszynska-Hoffmannowa and Alicja Okonska, *Six Thousand Miles Away: The Life and Art of Bolesław Czedekowski* (Łódż, 1978); Maria Borowiejska-Birkenmajerowa, *Bolesław Jan Czedekowski* (Kraków, 1994)

JAN KRZYSZTOF DAMEL

born about 1780 in Mitawa, Latvia

died 1840 in Minsk

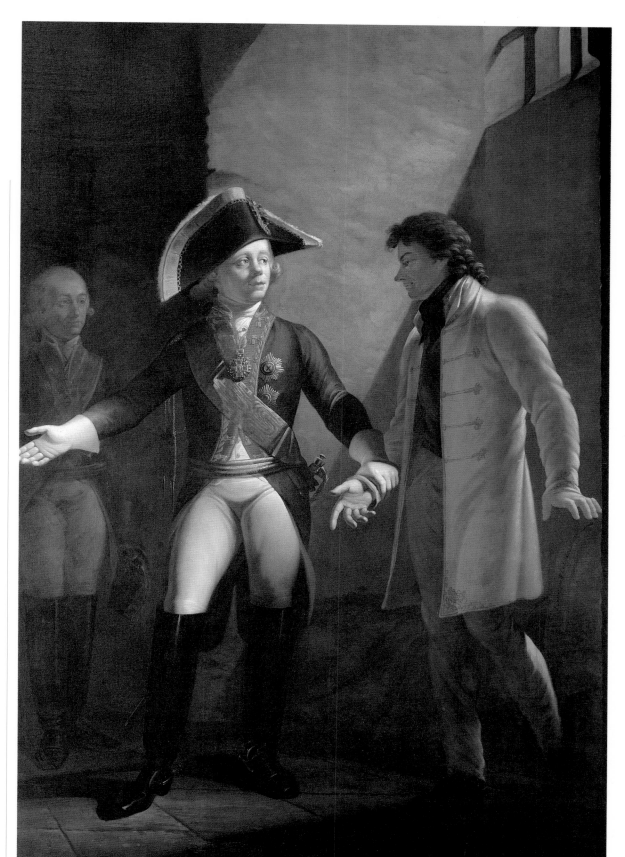

🖼 14

**Kościuszko
Released from
Russian Prison**

Oil on canvas
99 x 70 inches
Signed: J. Damel
1824 Minsk

*Donated by Dr. Anthony S.
Mallek in memory of his
parents, Szczepan and
Agnieszka Mallek, 1951*

*Tsar Paul rescinded the
imprisonment of
Kościuszko in 1796. In the
penumbra of Damel's
representation stands a
figure in princely military
uniform, perhaps King
Stanislaus Augustus
Poniatowski.*

40

Damel's childhood and school years were spent in Mitawa. At age twenty, he enrolled in the School of Fine Arts of the University of Wilno, where his studies were directed by Franciszek Smuglewicz and Jan Rustem. After he received his degree in 1809 he remained affiliated with the university as a teacher and the curator of its collection of drawings and etchings. In 1813 he became a candidate for the Masonic lodge known as "The Ardent Lithuanian," and is noted among its members from 1816, the year he took up residence in Minsk.

Implicated in the counterfeiting of Imperial Russian treasury notes along with Ignacy Julian and Feliks Ceyzik, Damel was exiled to Siberia. During the long journey to Tobolsk, he made sketches of the indigenous peoples he encountered along the way, as well as genre scenes, caricatures, and portraits of fellow deportees. He also painted portraits of local officials, among them the governor of Siberia, M. Speransky, through whose intervention he was later pardoned. While in Tobolsk, Damel painted landscapes and religious pictures; the latter included works for the Evangelical church in Tobolsk and the Bernardine church in Tomsk.

After his return from Siberia, Damel settled permanently in Minsk and devoted himself especially to scenes from Polish history. These compositions were clearly influenced by Smuglewicz, some based, in fact, on such specific works as *Pounding in of Border Stakes by Bolesław the Courageous* and *Entry into Kiev Through the Golden Gate*. Damel also availed himself of foreign models, as, for example, in the several versions of *Kościuszko Released from Russian Prison*, for which he utilized an engraving by Thomas Gaugain, after a drawing by Aleksander Orłowoski, and a mezzotint by J. Daniell, after a painting by H. Singleton.

Also important are the religious works painted for churches in the Wilno and Minsk regions and for private collectors. Damel also depicted scenes from the Hebrew Bible and classical mythology. Gifted with great facility and speed, he was able to turn out a large number of portraits of Wilno and Minsk landowners, the intelligentsia connected with the University of Wilno, clergy, and government officials. He tended, however, to be an uneven craftsman and to rely too heavily on the work of Smuglewicz and Rustem, whose styles are characterized by a certain coolness, stiffness, gravity, and lack of tonal harmony. His nature drawings, on the other hand, show considerable technical skill and a keen power of observation.

Damel's sizeable legacy also includes occasional pieces to mark the celebration of Masonic rites or the arrival of great personages—the entrance of Emperor Napoleon into Wilno, for example. Since so much of his oeuvre is scattered among the palaces, estates, and churches of the Wilno and Minsk regions, it has been difficult to determine its exact state of preservation.

BIBLIOGRAPHY

A. Melbechowska, "Dwie wystawy malarstwa polskiego w USA," *Biuletyn Historii Sztuki 3* (1960); M. Zakrzewska, "Obrazy malarzy polskich w zbiorach Fundacji Kościuszkowej w Nowym York," *Biuletyn Historii Sztuki 3* (1961); *Słownik Artystów Polskich* (entry by Janusz Derwojed and Lija Skalska), 2:5–9 (Wrocław, 1971).

JULIAN FAŁAT

born July 30, 1853, in Tuliglowy near Lwów
died July 9, 1929, in Bystra, Silesia

15

**Saint Anne's
Church in Warsaw**

Watercolor on board
27 x 20 inches
Signed: Fałat
1920

*Donated by Mr. Casimir A.
Silski, 1951.
Exhib.: Polish Painters
1850–1950, Montreal, 1984
(repr.).*

*The view is from
Marienstadt, the church as
seen from the presbytery.*

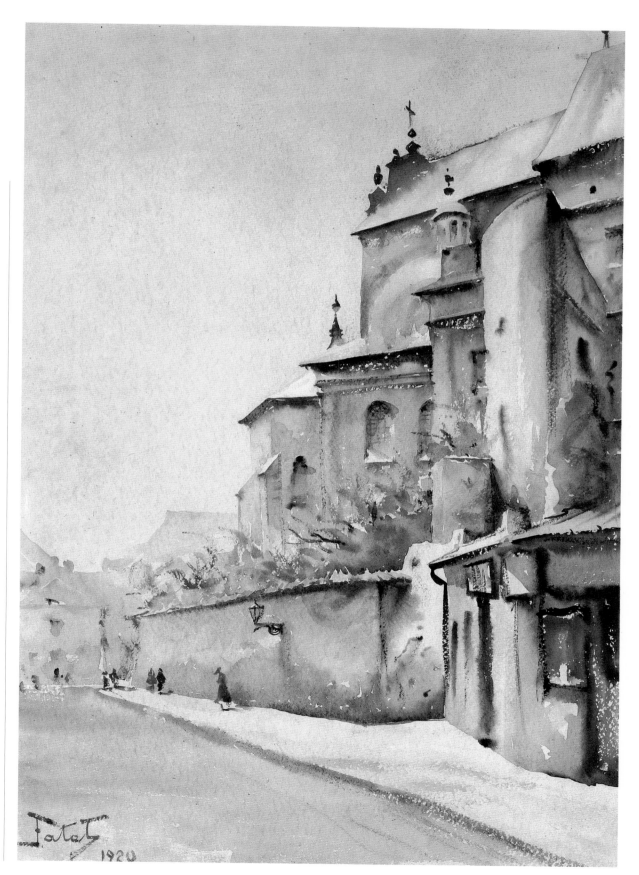

42

The son of a village organist, Fałat from earliest youth worked not only to earn his keep but also to pay for painting lessons. He studied at the School of Fine Arts in Kraków (1869–1871) and at the Munich Academy (1878–1880) under Alexander Strähuber and Georg Raab. While in Munich he became closely associated with the circle of Polish artists grouped around Józef Brandt. He traveled a great deal during this period, even making a trip around the world.

At the Radziwiłł estate at Nieświez, Fałat met the future German Kaiser, Wilhelm II, who invited him to work at the Imperial court in Berlin. He remained in the Kaiser's service for ten years. From 1895 to 1905 he was director of the School of Fine Arts in Kraków, which he succeeded in transferring into a full-fledged academy in 1900. He served as rector of the Academy for the next five years and introduced a number of modernizing curricular reforms.

Fałat's early work was predominantly illustrative. Later, under the influence of impressionism, his drafting technique and color sense underwent a significant change. His many hunting scenes give the impression of having been painted *en plein air*. His previous cool greens yielded to intense violets and blues. His favorite theme, repeated in many variations, is a winter landscape with a dark stream meandering through the white snow, showing bluish reflections and a rose-hued glimmer. During this period Fałat developed particularly as a watercolorist.

While in Berlin from 1894 to 1896, he and Wojciech Kossak painted the panorama *Napoleon Crossing the Berezyna in 1812*. He also made many seasonal views of Kraków and repeated landscapes featuring a small rural church.

Fałat was a distinguished portraitist whose subjects included the various members of his family and such prominent figures as Józef Piłsudski, Piłsudski's legionnaires, Józef Haller, and Władysław Sikorski. The latter group of portraits were featured in a 1917 exhibition at the Warsaw "Zachęta" Society of Fine Arts in honor of the Polish Legions, founded by Pilsudski during World War I.

Fałat belonged to the "Sztuka" Society of Polish Artists and participated in nearly all its Polish and foreign exhibitions. Most of his shows, however, were held at the "Zachęta," which mounted an anniversary exhibition in 1926. His works were displayed abroad in Paris, Berlin, Munich, Düsseldorf, and Venice and were accorded many awards and honors. Fałat's paintings are found in all larger Polish museums, as well as in private collections in Poland, England, Germany, and the United States. The great popularity of his work with collectors resulted in the appearance of many forgeries, especially after his death.

BIBLIOGRAPHY

Julian Fałat, *Memoirs*, ed. Stanisław Fałat (Warsaw, 1935); Maciej Masłowski, *Julian Fałat* (Warsaw, 1964); *Słownik Artystów Polskich* (entry by Hanna Bartnicka-Góska), 2:193–198 (Wrocław, 1975); Jerzy Malinowski, *Fałat* (Warsaw, 1983).

✂ BERNARD TADEUSZ FRYDRYSIAK

born November 20, 1908, in Warsaw
died May 4, 1970, in New York

🖼 16

**Portrait of Prof.
Stephen P. Mizwa**

Oil on canvas
46 x 36 inches
Signed: B. T. Frydrysiak
1948
Donated by the artist.

*Stephen P. Mizwa
(1892–1971), was born in
Rakszawa, Poland. He
emigrated to the United
States in 1910 and
received his B.A. from
Amherst College and A.M.
from Harvard College. He
served the Kosciuszko
Foundation from 1925
until his retirement in
1970.*

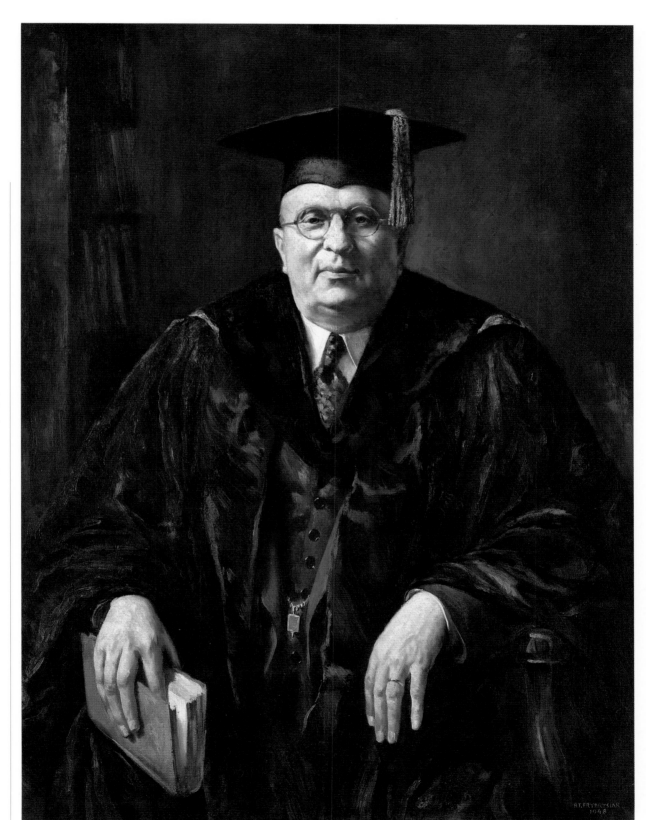

Frydrysiak began his studies at the Warsaw School of Fine Arts under Tadeusz Pruszkowski and Władysław Skoczylas. He made his debut in 1936 at the "Zachęta" Society of Fine Arts in Warsaw, at an exhibition of graphic artists known collectively as Czern i Biel ("black and white"). He was a member of the Association of Plastic Artists and, from 1938, the Brotherhood of Saint Luke, a group of young painters modeled after medieval painters' guilds and headed by Pruszkowski. The group also included Bolesław Cybis, Jan Gotard, Aleksander Jędrzejewski, Eliasz Kanarek, Jeremi Kubicki, Antoni Michałak, Stefan Płużański, Janusz Podoski, and Jan Zamojski. Frydrysiak and the other members of the Brotherhood were widely known for the seven large historical canvases that adorned the Polish Pavilion at the 1939 World's Fair in New York City.

Frydrysiak continued to exhibit in Warsaw until 1947, when he came to the United States at the invitation of Eleanor Roosevelt. His output after he left Poland declined considerably, and consists mainly of portraits, including two for the Kosciuszko Foundation: Dr. Henry Noble MacCracken, the Foundation's first President, and Prof. Stephen P. Mizwa, the Foundation's founder and second President. Frydrysiak also painted portraits of Gen. George C. Marshall and the Swedish diplomat Dag Hammarskjöld.

Frydrysiak's oeuvre comprises oil portraits, landscapes, interiors, and genre scenes, the last sometimes patterned after seventeenth-century Dutch models. His graphics are mostly woodcuts and drypoints heavily influenced by Japanese techniques.

ANTONI GRAMATYKA

born January 15, 1841, in Kalwaria Zebrzydowska
died December 24, 1922, in Kraków

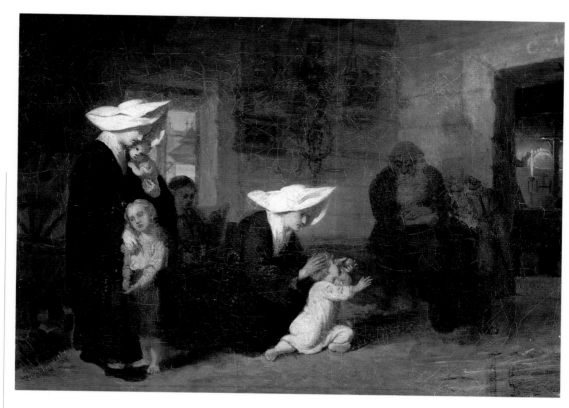

☑ 17

**Sisters of Charity
with Orphans**

Oil on board
11 x 16 inches
Signed lower right

*Donated by Frank Lukas-
Lukasiewicz.
Exhib.: American
International College,
Springfield, Massachusetts,
1992.*

After elementary school in Wadowice, Gramatyka apprenticed to a house painter in Kraków. He came to the attention of F. N. Bizanski, who taught him drawing in his studio. Gramatyka pursued more formal studies from 1858 to 1870 at the Kraków School of Fine Arts under Władysław Łuszczkiewicz and Jan Matejko. Under their supervision, he participated in the restoration of the Wit Stwosz altar in the Church of Saint Mary. In 1870 he received a stipend for further study in Vienna, where he won an award in 1872 for his painting of Saint Hedwig of Silesia aiding the victims of the Wrocław fire. Gramatyka returned to the Kraków School of Fine Arts in 1877–1879 to study composition with Jan Matejko, under whose direction he worked on polychromes for the Church of Saint Mary.

Beginning in 1866, Gramatyka exhibited regularly at the Society for the Fine Arts in Kraków, and from 1872 at the "Zachęta"

Society of Fine Arts in Warsaw. From 1872 to 1905 his works were also shown at the Lwów Society of Fine Arts.

Gramatyka worked in a variety of genres—landscapes, religious, historical, and genre scenes, and portraits—using oils, gouache, and pastel. He also designed murals, including the polychromes for the chapel of Queen Zofia in Wawel Castle and those in the Płock cathedral, for which he won an award in 1901.

Gramatyka exemplifies the realist school after Matejko, and he shares a taste for the narrative and didactic painting then widely popular. The linear elements in his compositions, however, together with the placement of the figure, show his receptivity to new trends in painting. His works can be found in the national museums of Kraków and Warsaw, the Lwów Picture Gallery, and in private collections.

BIBLIOGRAPHY

Słownik Artystów Polskich
2:455–457, (Wrocław 1975)

ALEKSANDER KONSTANTY GRYGLEWSKI

born March 4, 1833, in Brzostek near Jasło
died August 29, 1879, in Gdańsk

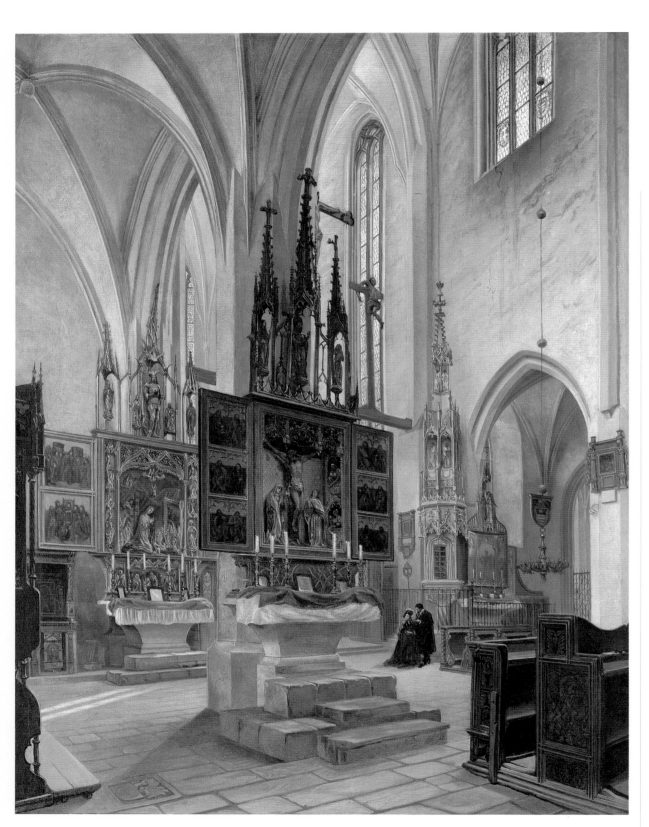

🖻 18

Interior of a Church

Oil on canvas
36 x 29 inches
Inscribed on the reverse
side: mal. Al. Gryglewski
i Jan Matejko
ca. 1863.

*Previously owned by Dr.
Iwanicki of Kraków.
Donated by Mrs. W. Sidney
Felton in memory of her
mother, Marianna
Szczechowicz, 1955
Exhib.: Polish Painters
1850–1950, Montreal, 1984
(repr.). Poland's Artistic
Heritage: Selected
Paintings from the
Kosciuszko Foundation,
Albright-Knox Gallery,
Buffalo, New York, 1992.
American International
College, Springfield,
Massachusetts, 1992.
Selected Paintings from the
Kosciuszko Foundation
Collection, Museum of Fine
Arts, St. Petersburg,
Florida, 1994.*

A church in Bardyszow, in the Slowacczyna region, has been suggested as the model for this work. Two small figures resembling Barbara Radziwill and King Sigismund Augustus stand under the high pulpit. Studies for the composition are in the National Museum in Warsaw.

Gryglewski studied at the Kraków School of Fine Arts (1852–1858) under Wojciech Korneli Stattler, Aleksander Płonczyński, and Władysław Łuszczkiewicz. After completing his studies, he and Jan Matejko traveled to Munich on a scholarship from Countess Zofia Potocka. He became a private student of G. Seeberger, professor at the Munich Academy, with whom he concentrated on paintings of the city's historical monuments.

In 1860 he returned to Kraków. With the help of Juliusz Kossak, Gryglewski secured a position as an illustrator for the Warsaw periodicals *Kłosy* and *Tygodnik Ilustrowany*, which he held from 1863 to 1875, after which he spent two years in Krosno. In 1877 he returned once more to Kraków, where he lectured on perspective at the School of Fine Arts. He remained in Kraków only a year, moving then to Gdansk for the last two years of his life.

Gryglewski painted historical architecture, interiors of churches, palaces, cityscapes, landscapes, and occasionally genre scenes. Distinguished by their masterful perspective, his cityscapes and interiors were especially esteemed. Gryglewski developed a close relationship with Jan Matejko, with whom he often collaborated. Matejko would execute, for example, the figures and incidental details in Gryglewski's paintings while Gryglewski would mark out the perspective in Matejko's. A good example of their collaboration is *Interior of a Church*, in the collection of the Foundation.

Gryglewski's paintings were exhibited in many Polish cities; he premiered in Kraków in 1855, in Warsaw in 1862, in Poznań in 1866, and in Lwów in 1870. He also showed in Paris, Vienna, and New York. His work can be found in many Polish museums and private collections.

47

BIBLIOGRAPHY

Słownik Artystów Polskich (entry by Aleksandra Melbechowska-Luty), 2:505–508 (Wrocław, 1975).

GUSTAW GWOZDECKI

born May 23, 1880, in Warsaw
died March 1935, in Paris

Gwozdecki came from a family with broad artistic interests, including theater. Although for financial reasons it was impossible for him to pursue formal study, his talent and perseverance gained him entry to the studio of Stanisław Grocholski in Munich. His youthful landscapes, exhibited in the Munich Kunstverein, won him the recognition of German critics. In 1900 he returned to Poland to study at the Kraków Academy of Fine Arts. He later became a student of Konrad Krzyzanowski. In 1903 his painting *The Angel Plowman*, which was exhibited at the "Zachęta" Society of Fine Arts, won him a letter of commendation and a stipend for further study in Paris. Although he remained abroad, he maintained personal and artistic contacts with Poland.

19

French Riviera

Oil on board
10 x 13 inches
Unsigned
ca. 1928

☺ 20

Head of a Woman

Pencil on paper
10 x 8 inches
Unsigned
ca. 1928

☺ 21

Nude

Pencil on paper
10 x 8 inches
Unsigned
ca. 1928

Gwozdecki created a stir with his showings in the Parisian salons. For an exhibition mounted in his own studio in Paris, Andrée Salmon wrote the preface to the catalogue and Apollinaire included an excerpt from his review in *L'Intransigean.* Gwozdecki had one-man shows in Poznan (1907) and in Kraków (1908).

For the boldness of his colors and technique, as well as for his expressive sculptures, Gwozdecki was counted among the revolutionary artists of the period. He was invited to participate in the First Exhibition of Polish Expressionists, organized by avant-garde artists in Kraków in 1917. Gwozdecki left Paris in 1916 to spend time in New York, where he exhibited several works. In 1928 the Committee for Polish-American Relations elected him its president. A sizeable collection of his graphics was purchased by the New York Public Library in 1932. Gwozdecki also contributed critical pieces to Polish and French periodicals and wrote a book entitled *On Evolution in Art.*

VLASTIMIL HOFFMAN

born April 24, 1881, in Prague
died March 6, 1970, in Szklarska Poręba

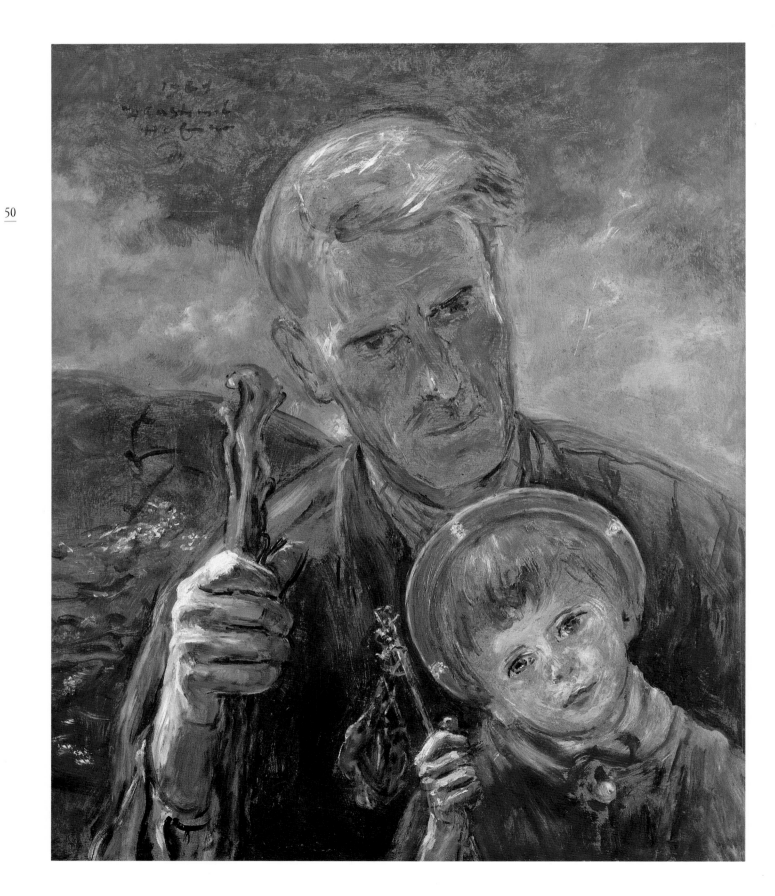

☑ 22

Saint Christopher and the Child Jesus

Oil on composition board
22 x 19 inches
Signed: Vlastimil Hoffman, 1961
Donated by the artist, 1961.

Hoffman came to Kraków in 1889, and in 1895, while still in secondary school, he attended evening drawing lessons in Florian Cynk's studio at the Kraków School of Fine Arts. From 1896 to 1898 he studied painting at the school under Jan Stanisławski and Jacek Malczewski. He then went to Paris, where he worked with Jean Léon Gérome at the Ecole des beaux-arts, returning to Kraków in 1901 to further his studies under Leon Wyczółkowski. In 1906 Hoffman himself taught the evening drawing classes at the Kraków Academy of Fine Arts.

From 1904 Hoffman was a member of the "Manes" Association of Czech Artists. He founded the "Group of Five" in 1905, cofounded the group "Zero" in 1908, and in 1911 became a member of the "Sztuka" Society of Polish Artists. He also belonged to the art group "Odłam," the Viennese Secession, and the Parisian Société nationale des beaux-arts. Besides participating in the programs of these groups, he also exhibited with the Kraków Society of Friends of the Fine Arts (beginning in 1902), with the Warsaw "Zachęta" Society of Fine Arts (beginning in 1906), and in many showings of Polish art abroad (Munich, Rome, Padua, and Buffalo). He had a number of one-man shows; three in Wrocław (1950, 1960, 1967) were the most comprehensive.

Hoffman lived in Prague during World War I and in Kraków in the interwar years, visiting Italy in 1934. His service in the Czech Legion in World War II carried him from Tarnopol to Palestine. In 1946 he returned to Kraków via Prague and that same year settled in Szklarska Poręba.

Hoffman painted traditional figurative subjects (including a Madonna in folk style), landscapes, and portraits. The influence of Jacek Malczewski, especially in the handling of light, is sometimes evident, as in *Saint Christopher and the Child Jesus*, from the Foundation's collection.

Hoffman's paintings are in major museums in Poland, as well as in private collections in Poland and abroad (Czech Republic, France, Germany, and the United States).

BIBLIOGRAPHY

Bohdan Czajkowski, *Portret z pamięci* (Wrocław, 1971).

❧ APOLONIUSZ KĘDZIERSKI

born July 1, 1861, in Suchedniów near Kielce
died September 2, 1939, in Warsaw

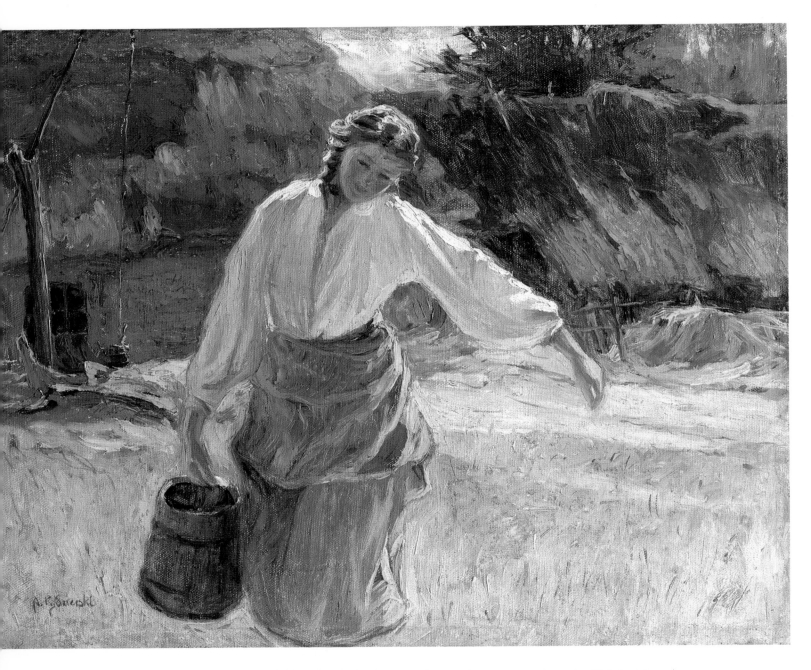

Kędzierski spent his childhood and school years in Radom. In 1877 he began taking his summer vacations at Oronsk, the estate of the artist Józef Brandt, who became his first teacher. Until 1885, he studied in the Warsaw Drawing Class under Wojciech Gerson and Aleksander Kamiński. Financial support from Brandt enabled him to continue his studies at the Munich Academy (1885–1888). Warsaw became his permanent home in 1899; he left for any length of time only in 1902, for a series of study trips to Belgium, France, Italy, Austria, and Hungary.

Kędzierski was a member of the "Sztuka" Society of Polish Artists, the artistic groups "Odłam" and "Pro Arte," and the Club of Polish Watercolorists. He also served with activist organizations such as the Committee

🖻 23

The Old Oaken Bucket

Oil on canvas
laid on wood
17 x 22 inches
Signed: A. Kędzierski
Undated

Donated by friends in memory of "Wladzia" Alice Aszurkiewicz, 1969. Exhib.: Salon de Société des beaux arts, Paris, 1921. Polish Painters 1850–1950, Montreal, 1984 (repr.) Poland's Artistic Heritage: Selected Paintings from the Kosciuszko Foundation, Albright-Knox Gallery, Buffalo, New York, 1992. American International College, Springfield, Massachusetts, 1992. Selected Paintings from the Kosciuszko Foundation Collection, Museum of Fine Arts, St. Petersburg, Florida, 1994.

Another version of this work is in the National Museum in Warsaw.

of the Society for the Promotion of the Fine Arts and the Art Board of the Institute for the Propagation of Art in Warsaw.

Kędzierski's works were shown domestically in Kraków, Lwów, Poznań, and Warsaw, and abroad in Berlin, Paris, Chicago, and New York. He painted mostly oils and watercolors, and his favored subjects were the landscape and peasant life of the countryside, especially the Mazowsze and Polesie regions.

At the turn of the century, with Zdzisław and Stanisław Jasiński he executed numerous polychromes in churches on commission for the Historical Landmarks Preservation Society. He also designed the interiors and furnishings of several elegant Warsaw coffeehouses, including the Udialowa coffeehouse on the corner of Nowy Swiat Street and Jerozolimski Avenue. Kędzierski's interest in drawing and illustration is apparent in the many pieces he published in *Tygodnik Ilustrowany* (1880–1887) and his watercolor illustrations (1928) for Władysław Reymont's celebrated novel *The Peasants*. He also wrote a number of articles and studies, including a reminiscence of Józef Brandt (1900) and a book about his friend and colleague Zdzisław Jasiński (Warsaw, 1934).

BIBLIOGRAPHY

M. Zakrzewska, "Obrazy polskich w zbiorach Fundacji Kosciuszkowskiej," *Biuletyn Historii Sztuki 3* (1961).

JULIUS KOSSAK

born December 15, 1824, in Nowy Wiśnicz near Bochnia
died February 3, 1899, in Kraków

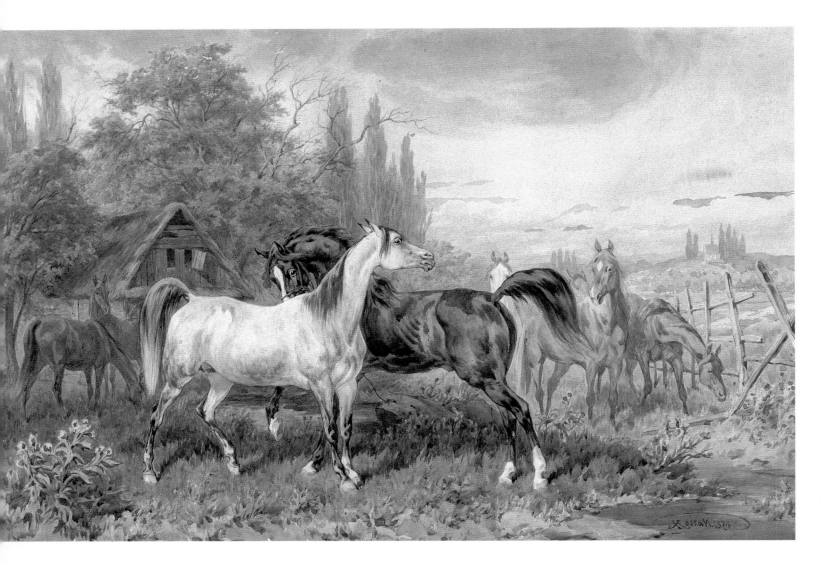

Juliusz Kossak was the senior member of an artistic Galician family renowned for its contributions to Polish painting and literature. In 1842, while a law student in Lwów, he began art studies with Jan Maszkowski. From 1844 to 1850, with the help of Kazimierz and Juliusz Dzieduszycki and Gwalbert Pawlikowski, he established contacts with the gentry and began a journey through the estates and palaces of Volhynia, Podolia, and the Ukraine. This period yielded a number of magnificent landscapes and scenes from country life. He befriended the writer Szczęsny Morawski and the painter Piotr Michałowski, availing himself of the latter's artistic advice.

From 1850 to 1852 he lived first in Lwów, where he studied drawing with Artur Grottger, and then in Warsaw, making occasional journeys to Vienna, Hungary, and Saint Petersburg. He lived four years in Paris (1856–1860), where he met the painter Horace Vernet and became friends with Józef Brandt.

After returning to Warsaw in 1862, he was appointed artistic director of *Tygodnik Ilustrowany*, a position he held until 1868. He also taught drawing privately and at Maria Lubieńska's Drawing School for Women. In 1869, he went to Munich, where he worked in the studio of Franz Adam. Toward the end of that year he settled permanently in Kraków,

24

The Dzieduszycki Stable

Watercolor on paper
14 x 23 inches
Signed:
J. Kossak 1874

Donated by Mme. Ganna Walska in 1954. Exhib.: Polish Painters 1850–1950, Montreal, 1984 (repr.). Poland's Artistic Heritage: Selected Paintings from the Kosciuszko Foundation, Albright-Knox Gallery, Buffalo, New York, 1992. American International College, Springfield, Massachusetts, 1992. Selected Paintings from the Kosciuszko Foundation Collection, Museum of Fine Arts, St. Petersburg, Florida, 1994.

taking an active role in the city's cultural life. He was one of the organizers of the National Museum and president of the Artistic-Literary Circle. Anniversary celebrations in his honor in Warsaw and Kraków were a testimony to his popularity. His works were displayed in numerous Polish and foreign exhibitions, including one-man shows and posthumous retrospectives in Lwów, Kraków, and Warsaw. An exhibition of all three Kossaks toured the major cities of Poland in 1932–1933. Similar exhibitions were organized in Poznan in 1976 and in Słupsk in 1977.

Juliusz Kossak painted military and historical compositions, genre scenes, portraits of horsemen, and, most of all, horses. His equestrian works show a masterful knowledge of the animals' anatomy and great feeling for their movement.

He treated his subjects in an anecdotal, sentimental, or humorous manner. A master draftsman and watercolorist, he was also well known for his illustrations for works by writers such as Adam Mickiewicz, Wincenty Pol, and Józef Ignacy Kraszewski, and for various periodicals, including *Kłosy, Tygodnik Ilustrowany* and *Przyjaciel Dzieci*.

BIBLIOGRAPHY

J. Borowski-Skarbek, *Juliusz Kossak* (Kraków, 1900); Przemysław Michałowski, ed., *Juliusz, Wojciech, Jerzy Kossakowie* (Słupsk, 1977); Maciej Mastowski, *Juliusz Kossak* (Warsaw, 1984); J. Zielinska, Dzieła Kossaków; *Juliusza, Wojciecha, Jerzego* (Warsaw, 1984); *Słownik Artystów Polskich* (entry by Hanna Kubaszewska), vol. 4 (Wrocław, 1985).

WOJCIECH KOSSAK

born December 31, 1856, in Paris
died July 29, 1942, in Kraków

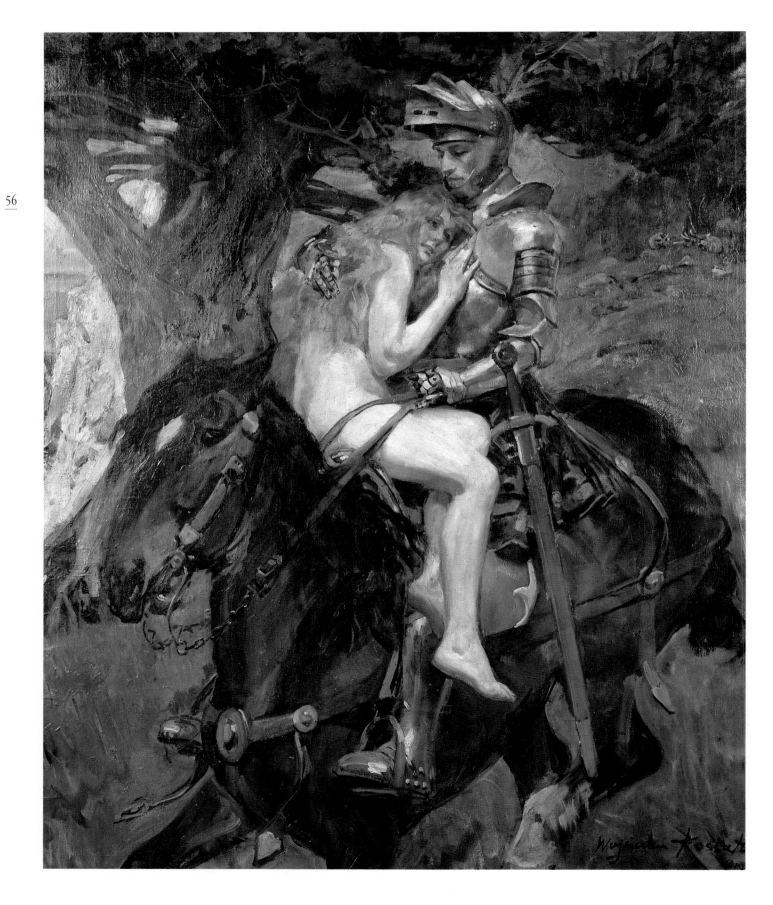

🖻 25

The Knight and the Maid

Oil on canvas
46 x 39 inches
Signed: Wojciech
Kossak,1930

*Gift of Dr. & Mrs. John A.
Cetner in memory of
Edward & Jeanette
Witkowski.*

Scion of artist Juliusz Kossak, who gave him his first lessons in drawing, Wojciech Kossak spent his childhood in Paris, then moved with his family to Warsaw in 1861 and to Kraków in 1869. From 1871 to 1873 he studied at the School of Fine Arts in Kraków under Władysław Łuszczkiewicz, from 1874 to 1876 at the Munich Academy under Alexander Strähuber and Alexander Wagner, and from 1877 to 1883 in Paris with Léon Bonnat and Alexandre Cabanel. Between his studies in Munich and Paris, he served in the Kraków Uhłan Division and attained the rank of officer. It was from this service that he acquired a fondness for military subjects—maneuvers, reviews, cavalry charges. From 1884 to 1895 he lived in Kraków, and then worked until 1902 for Emperor Wilhelm II in Berlin. He made short trips to Spain, Egypt, England, and the United States.

While resident in Kraków from 1907 to 1914, he took an active part in the city's artistic life. He was a member of the Society of Artists, a cofounder of the art group "Zero," and president of the Society of Friends of the Fine Arts. From 1915 to 1919, he was a professor in the School of Fine Arts in Warsaw and from 1921 maintained a studio in the Hotel Bristol in that city. He visited the United States six times between 1920 and 1934 and received many portrait commissions there.

Wojciech Kossak's art, shaped first by the influences of his father and Józef Brandt, eventually became entirely his own. He was renowned particularly for the bravura of his compositions. He exhibited in Kraków, Lwów, Warsaw, Paris, Vienna, Munich, Berlin, Saint Petersburg, Moscow, and Rome. He was honored with the Cross of Franz Józef I, the Commander's Cross of the Order of Polonia Restituta, and in 1901 the French Legion of Honor. He was also a laureate of the Art Award of the City of Warsaw.

Working mostly in oils and watercolor, Kossak favored military subjects from the Napoleonic era and the Polish November Insurrection of 1830–1831. He was also a fashionable and much-in-demand portraitist whose sitters included such military figures as Marshal Ferdinand Foch and the American generals John Pershing (commissioned by the United States Military Academy at West Point) and Edward M. House. Kossak also found time, while in the United States, to portray American film stars on horseback and genuine cowboys "in action." He participated with other artists in painting the *Raclawice Panorama* in Lwów, which was exhibited on the one hundredth anniversary of the Kościuszko Insurrection in 1894 (the *Panorama* now hangs in its own museum in Wrocław). Other panoramas include *Napoleon Crossing the Berezyna in 1812* and *The Battle Beneath the Pyramids*. His legacy of about two thousand paintings is held mostly in private collections in Poland and abroad.

Wojciech Kossak was the father of the painter Jerzy Kossak, the poetess Maria Pawlikowska-Jasnorzewska, and the writer Magdalena Samozwaniec.

BIBLIOGRAPHY

K. Olszański, *Wojciech Kossak: Reminiscences* (Warsaw, 1971); K. Olszański, *Wojciech Kossak* (Wrocław, 1976): Przemysław Michałowski, ed., *Juliusz, Wojciech, i Jerzy Kossakowie* (Słupsk, 1977); J. Zielińska, *Dziela Kossaków, Juliusza, Wojciecha, Jerzego* (Warsaw, 1984); *Słownik Artystów Polskich* (entry by Hanna Kulbaszewska), vol. 4. (Wrocław, 1985).

❧ JERZY KOSSAK

born September 11, 1886, in Kraków
died May 11, 1955, in Kraków

BIBLIOGRAPHY

Przemysław Michałowski,
ed., *Juliusz, Wojciech,
Jerzy Kossakowie* (Słupsk,
1977); J. Zielinska, *Dzieła
Kossaków. Juliusza,
Wojciecha, Jerzego*
(Warsaw, 1984); *Słownik
Artystów Polskich* (entry by
Irena Balowa), vol. 4
(Wrocław, 1985).

Kossak learned painting at a very young age under the tutelage of his father, Wojciech Kossak, and his grandfather, Juliusz Kossak. These familial studies took the place of a formal artistic education. During World War I he served as a lieutenant in a regiment of Austrian light cavalry, and later in a panzer division on the Italian front. After the war, he affirmed family tradition and devoted himself to an artistic career. His paintings appealed to viewers more for their content and humor than for their formal achievement. The fame of his father and grandfather had a definite influence on the great demand for his work.

Kossak was an extraordinarily prolific artist, often repeating a theme over and over, unconcerned with giving it any deeper artistic treatment. His favorite subjects were a mounted uhlan and girl, peasant weddings, and genre scenes. He also created larger works treating historical and military themes from both the Napoleonic period and World War I. His works were shown at many Polish and foreign exhibitions, including Buffalo (1932) and Berlin (1937). In 1932–1933 a large exhibition of paintings by all three Kossaks toured all the larger cities of Poland. A similar exhibition was mounted in Poznań in 1976 and in Słupsk in 1977. In 1953 Kossak took part in an exhibition in Warsaw dedicated to the tenth anniversary of the Polish People's Army.

Kossak never left his native Kraków for any length of time, content to paint in the family villa, "Kossakowa," for more than half a century.

🖪 26

**Polish Uhlan and
Russian Cossack**

Oil on cardboard
8¼ x 12¼ inches
Signed: Jerzy Kossak
1931

*Donated by Mrs. W. Sidney
Felton, 1956.
Exhib.: Poland's Artistic
Heritage: Selected
Paintings from the
Kosciuszko Foundation,
Albright-Knox Gallery,
Buffalo, New York, 1992.
Selected Paintings from the
Kosciuszko Foundation
Collection, Museum of Fine
Arts, St. Petersburg,
Florida, 1994.*

born April 14, 1826, in Warsaw
died September 30, 1911, in Warsaw

🖼 27

The Apple Orchard

Oil on canvas
laid on wood
20 x 30 inches
ca. 1894

*Donated by Mr. Kazimierz
Jarzębowski for his wife
Florentyna, 1959.
Exhib.: Polish Painters
1850–1950, Montreal 1984
(repr.). Poland's Artistic
Heritage: Selected
Paintings from the
Kosciuszko Foundation,
Albright-Knox Gallery,
Buffalo, New York, 1992.
American International
College, Springfield,
Massachusetts, 1992.
Polish Paintings from the
Kosciuszko Foundation
Collection, Museum of Fine
Arts, St. Petersburg,
Florida, 1994.*

Kostrzewski studied painting from 1844 to 1849 at the Warsaw School of Fine Arts under Chrystian Breslauer, Aleksander Kokular, Rafał Hadziewicz, Marian Zaleski, and Feliks J. Piwarski. During this period he became involved with a group of young bohemian painters who were striving to introduce realism into Polish art: Marcin Olszynski, Wojciech Gerson, Ignacy Gierdziejewski, Józef Brodowski, Henryk Pillati, Józef Szermentowski, and Juliusz Kossak. Kostrzewski joined them on their field trips to the outskirts of Warsaw and on summer vacations in the Holy Cross Mountains, Ojców, and Lithuania. In 1849 he was in Kielce as a guest of the collector Tomasz Zieliński. Kostrzewski copied paintings in his patron's gallery, while also giving lessons to Szermentowski. A tour of Europe in 1856 took him to Dresden, Berlin, Vienna,

Brussels, and finally Paris, where he was strongly attracted to French and Dutch genre painting. After returning to Warsaw, Kostrzewski was active as a teacher, holding drawing classes in aristocratic homes (clients included the Potocki, Zamoyski, Lubomirski, and Plater families) and in 1868 becoming instructor at Maria Lubienska's school.

Kostrzewski's oeuvre includes landscapes executed in oil and watercolor, genre scenes, and caricatures. He took a particular interest in illustration after 1856 and created an entire gallery of caricatures of Warsaw types. His satirical drawings and everyday scenes were published in the Warsaw periodicals *Tygodnik Ilustrowany, Biesiada Literacka, Wędrowiec, Kłosy, Mucha, Kolce,* and *Szczutek.* He also illustrated books by Adam Mickiewicz, Józef Ignacy Kraszewski, Władysław Syrokcymla, and Henryk Sienkiewicz.

BIBLIOGRAPHY

Irena Jakimowicz, *Franciszek Kostrzewski* (Warsaw, 1952); Irena Tessaro-Kosimowa, *Warsaw and Its Inhabitants in the Art of Franciszek Kostrzewski* (Warsaw, 1968); *Słownik Artystów Polskich* (entry by Aleksandra Melbechowska-Luty), vol. 4 (Wrocław, 1985).

ALEKSANDER KOTSIS

born May 30, 1836 in Ludwinów (now part of Kraków)
died August 7, 1877, in Podgórze (now part of Kraków)

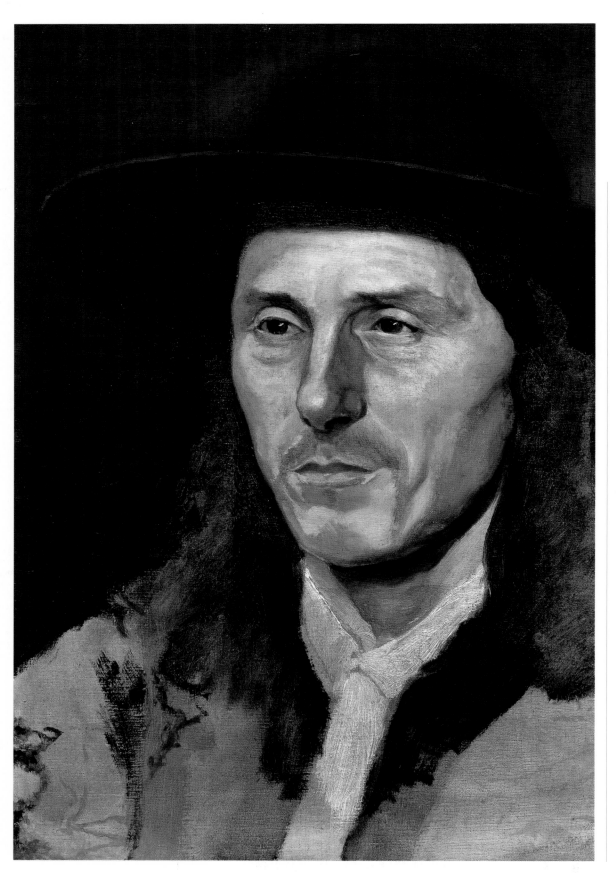

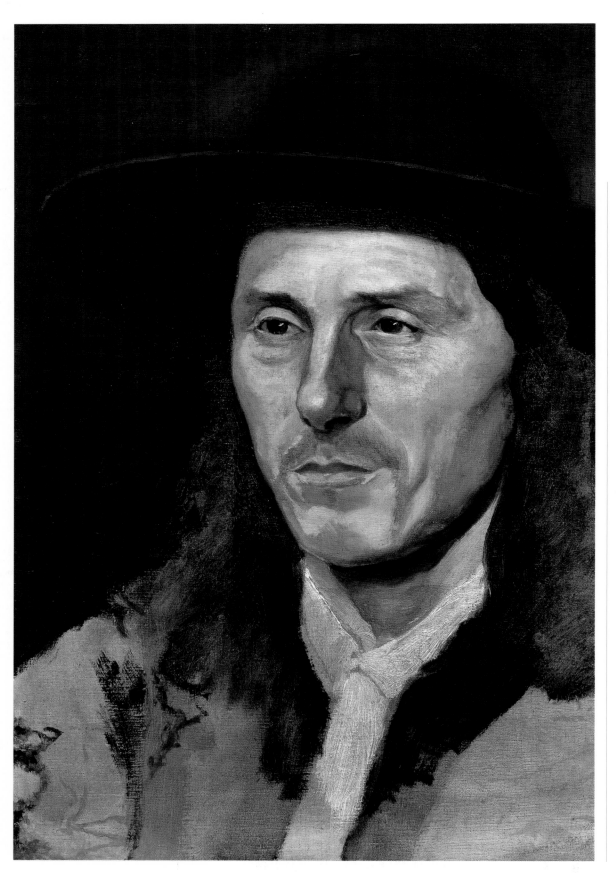 28

Polish Mountaineer

Oil on canvas
18 x 12 inches
Unsigned
ca. 1867

*Donated by friends in
memory of 'Władzia' Alice
Aszurkiewicz, 1969.
Exhib.: Polish Painters
1850–1950, Montreal, 1984
(repr.). Selected Paintings
from the Kosciuszko
Foundation Collection,
Museum of Fine Arts, St.
Petersburg, Florida, 1994.*

*The subject is a highlander
from the Podhale region of
southern Poland.*

From 1850 to 1860 Kotsis studied drawing and painting at the Kraków School of Fine Arts with Wojciech Korneli Stattler, Władysław Łuszczkiewicz, and Aleksander Płończyński. During this period he maintained close ties with artists Jan Matejko, Artur Grottger, Izydor Jabłoński, and Władysław and Stanisław Tarnowski. He was known for his fondness for the landscape and people of the region of the Tatra Mountains. Kotsis took additional training in Vienna in 1861–1862 with Ferdinand Georg Waldmüller. After settling in Kraków, he made additional trips to Paris, Brussels, Austria, and the Alps. Later residence in Munich, between 1871 and 1875, offered the opportunity to visit the mountains of Bavaria and the Tyrol. He belonged to the Munich Kunstverein. In his tours of European galleries he took a particular interest in seventeenth-century Dutch painting.

Kotsis painted landscapes and portraits, but concentrated on genre scenes from the districts around Kraków and Podhale. Painted in dark tones with cold silvery highlights, these works, though at moments sentimental, reveal a distinctly poetic and tender rapport with the poorer inhabitants of the region, particularly the children. After 1863, he treated episodes from the January Insurrection and the subsequent Russian repression.

Kotsis's works were exhibited in Warsaw, Kraków, Lwów, and Vienna. He had several one-man shows, and scholarly retrospectives were mounted in Lublin in 1959 and at the Museum of Central Pomerania in Słupsk in 1969.

BIBLIOGRAPHY

Jerzy Zamoziński, *Aleksander Kotsis* (Warsaw, 1953); Jerzy Zamoziński, *Aleksander Kotsis 1836–1877: A Monographic Exhibit* (Lublin, 1959); *Słownik Artystów Polskich* (entry by Jolanta Polanowska), vol. 4 (Wrocław, 1985).

ALFRED WIERUSZ-KOWALSKI

born October 11, 1849, in Suwałki
died February 16, 1915, in Munich

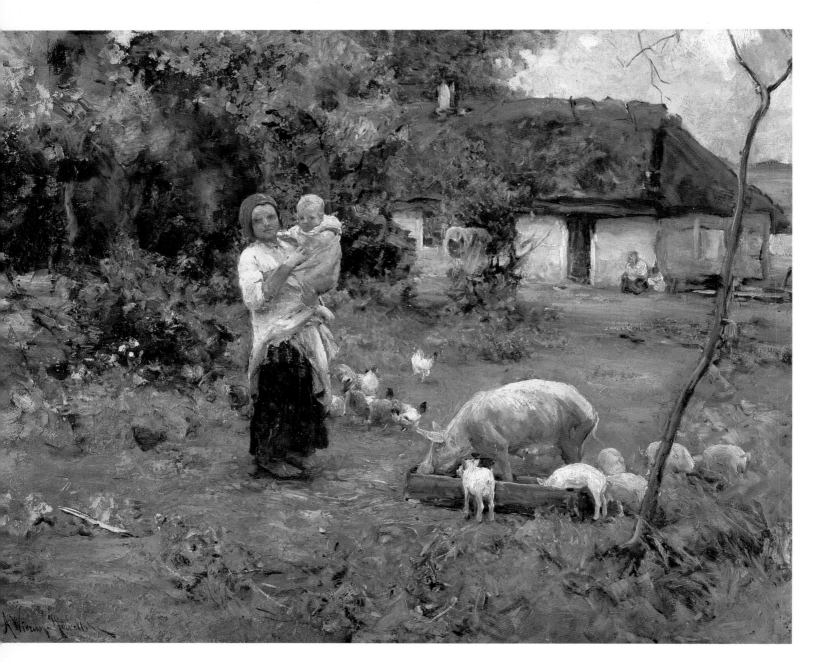

*Donated by Mr. & Mrs.
Joseph Kluz, 1951.
Exhib.: Polish Painters
1850–1950, Montreal, 1984
(repr.). Poland's Artistic
Heritage: Selected Paintings
from the Kosciuszko
Foundation, Albright-Knox
Gallery, Buffalo, New York,
1992. American Interna-
tional College, Springfield,
Massachusetts, 1992.
Selected Paintings from the
Kosciuszko Foundation
Collection, Museum of Fine
Arts, St. Petersburg,
Florida, 1994.*

Wierusz-Kowalski received his first drawing lessons in Kalisz from S. Barcikowski. From 1868 to 1870 he studied in the Warsaw Drawing Class under Rafał Hadziewicz, Aleksander Kamiński, and Wojciech Gerson, and from 1871 to 1872 in Dresden and Prague, where he received commissions from the well-known dealer Lehmann. From Prague he went to Munich, where he trained at the Munich Academy under Alexander Wagner and Józef Brandt. Wierusz-Kowalski's success with Munich collectors inspired him to settle permanently in the Bavarian capital. He maintained relations with other of his countrymen in the city and returned often to Poland, especially after acquiring the estate of Mikorzyn in Wielkopolska (Great Poland) around 1897. He became an honorary professor at the Munich Academy in 1900 and showed at international exhibitions in

29

On the Farm

Oil on cardboard
20 x 27 inches
Signed:
A. Wierusz-Kowalski
ca. 1900

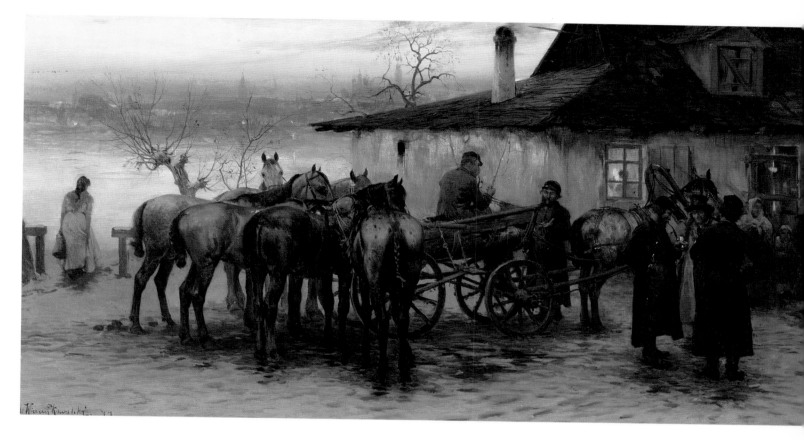

⌨ 30

The Horse Fair

Oil on wood panel
12 x 24 inches
Signed: Al. Wierusz-
Kowalski '77

*Donated by Mr. & Mrs. Jan
Janowski, 1958.
Exhib.: Polish Painters
1850–1950, Montreal, 1984
(repr.). Poland's Artistic
Heritage: Selected
Paintings from the
Kosciuszko Foundation,
Albright-Knox Gallery,
Buffalo, New York, 1992.
Selected Paintings from the
Kosciuszko Foundation
Collection, Museum of Fine
Arts, St. Petersburg,
Florida, 1994.*

Munich, Berlin, and Vienna. Prominent galleries and public collections that acquired his work included the Neue Pinakothek in Munich and museums in Dresden, Antwerp, and the United States.

A prototypical representative of the so-called Munich school of Polish artists, Wierusz-Kowalski painted mostly genre scenes and hunting scenes with an equestrian focus. His greatest success with collectors, however, came with his nocturnal winter landscapes—moonlit scenes of sleighs being attacked by a lone wolf or a pack of wolves. Unable alone to keep up with his commissions, he relied on help from his nephew Karol and the painter Marian Trzebinski. Wierusz-Kowalski was married to Jadwiga Szymanowska, daughter of the sculptor Wacław Szymanowski. Their son, Czesław, was also a painter.

BIBLIOGRAPHY

Słownik Artystów Polskich
(entry by Janusz Derwojed),
vol. 4 (Wrocław, 1985).

❧ ANIELA LEWANDOWSKA

born March 30, 1896, in Warsaw
died December 7, 1953 in Paris

In 1910 Lewandowska began studying at the Wanda Ciech-Mazowiecka School of Painting in Warsaw. After World War I, she and her husband, Ludwik, left for Paris. She continued her studies at the Ecole du Louvre and the Académie Montparnasse and also befriended Olga Boznańska and Tadeusz Makowski. During World War II, she took an active role in the Service social d'aide aux emigrants and the Association of Polish Artists in France.

Lewandowska painted portraits, landscapes, still lifes, streets scenes, and interiors, including the salon of Władysław Mickiewicz, the son of the poet Adam Mickiewicz. She exhibited at the Salon d'automne in 1942 and the Salon des indépendants in 1948, 1950, 1952, and 1953. In 1948 she participated in an exhibition organized by the Franco-Polish Friendship Society. Part of Lewandowska's legacy resides in the Historical-Literary Society in Paris. The artist's personal portfolio, containing a reproduction of her handwritten auto-biography, can be found in the collection of the Art Institute of the Polish Academy of Sciences in Warsaw.

BIBLIOGRAPHY

Kultura 6 (1948): 161;
*Biuletyn Informacyjny
Związku Artystów Polskich
we Francjí* (Paris, 1957),
13: 7–8.

🖾 31

Still Life with Blossoms

Oil on canvas
23 X 28 inches
Signed: A. Lewandowska

Donated by Mr. George Szabad.

❧ JACEK MALCZEWSKI

born July 15, 1854, in Radom
died October 8, 1929, in Kraków

⊡ 32

**Self Portrait with a
Black Hat**

Oil on cardboard
19 x 13 inches
Signed: J. Malczewski
1919

*Exhib.: Polish Painters
1850–1950, Montreal, 1984,
(repr.). Poland's Artistic
Heritage: Selected
Paintings from the
Kosciuszko Foundation,
Albright-Knox Gallery,
Buffalo, New York, 1992.
Selected Paintings from the
Kosciuszko Foundation
Collection, Museum of Fine
Arts, St. Petersburg,
Florida, 1994.*

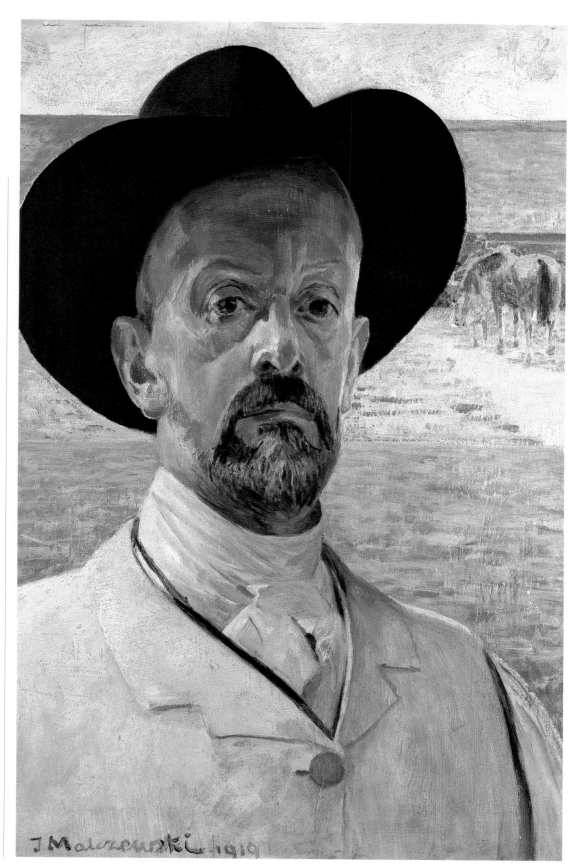

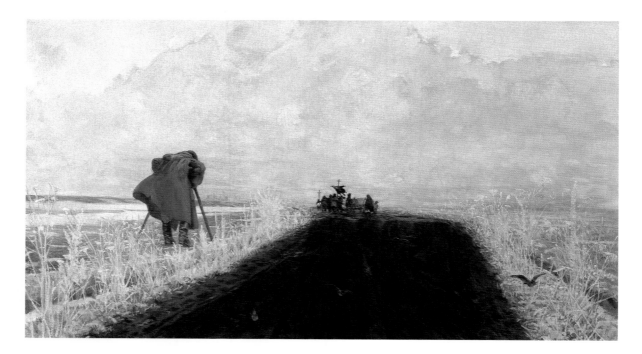

Among visual artists, Malczewski was a leading light of both the Young Poland movement and the Polish variant of the symbolist movement. He studied at the Kraków School of Fine Arts (1873–1876) with Władysław Łuszczkiewicz, Feliks Szynalewski, and Jan Matejko. After additional training in Paris under E. Lehmann, he resumed his studies in Kraków (1877–1879). While in Munich (1885–1886), he maintained close contacts with Józef Brandt and Alfred Wierusz-Kowalski.

By 1879 Malczewski had his own studio in Kraków and had befriended the painters Witold Pruszkowski, Maurycy Gottlieb, and Kazimierz Pochwalski. From 1884 to 1885 he served as a draftsman on a scientific expedition to Asia Minor organized by Karol Lanckoroński and Marian Sokołowski. The surviving drawings were published in a volume edited by Mieczysław Paszkiewicz in 1972 (London: Poets and Painters Press). The drawings, which were for many years in the Polish Library in London, are now in the permanent collection of the Wawel Castle in Kraków.

Malczewski was a cofounder of the "Sztuka" Society of Polish Artists and from 1908 a member of the board of the art group "Zero." He was professor (1897–1900) and then rector (1912–1914) at the Academy of Fine Arts in Kraków. In 1895, he and Wincenty Wodziński directed the A. Baraniecki Higher Courses for Women in Kraków.

The first of many one-man shows was mounted in 1903. A scholarly retrospective was organized by the National Museum in Poznań in 1968. In 1921 he was awarded the Order of Polonia Restituta, and in 1928 the Art Award of the City of Warsaw. He was buried in the Crypt of Merit on Mount Skałka in Kraków.

Early in his career, Malczewski painted in a realist style, often addressing in tonally dark works the martyrdom of the Polish deportees to Siberia after the January Insurrection of 1863. Examples are *Sunday in the Mine* (1881), *The Death of Ellenaia* (1883), and *The Christmas Eve Supper of the Deportees* (1892). From about 1900, he began treating the same material in works incorporating mythological elements. Historical persons, including those whose portraits he had painted, appear alongside chimeras, fauns, centaurs, and angels. Among the best known are *Melancholy* (1890–1894) *and Blind Circle* (1895–1897). Malczewski is also the author of some 150 portraits of subjects in various guises, including a number of self-portraits as the suffering Christ.

Malczewski's work can be found in all the larger Polish museums and in private collections in Poland, Germany, England, France, and the United States. His son Rafał was also a painter.

BIBLIOGRAPHY

A. Heydel, *Jacek Malczewski: Człowiek i artysta* (Kraków, 1933); Andrzej Jakimowicz, *Malczewski i jego epoka* (Warsaw, 1971); Kazimierz Wyka, *Thanatos i Polska, czyli o Jacku Malczewskim* (Kraków, 1971); Mieczysław Paszkiewicz, ed., *Jacek Malczewski in Asia Minor and in Rozdol* (London, 1972); Andrzej Jakimowicz, *Jacek Malczewski* (Warsaw, 1974); Agnieszka Lawniczakowa, *Jacek Malczewski* (Warsaw, 1976); Stanisław Stopczyk, *Jacek Malczewski* (Warsaw, 1984); Barbican Gallery, *Malczewski, A Vision of Poland* (London, 1990).

🖾 33

The Final Journey

Oil on canvas
25 x 44 inches
Signed: J. Malczewski
1894

Donated by Mr. John Malinowski in memory of his mother Zofia Malinowska, 1951. Exhib.: Polish Painters 1850–1950, Montreal, 1984, (repr.). Poland's Artistic Heritage: Selected Paintings from the Kosciuszko Foundation, Albright-Knox Gallery, Buffalo, New York, 1992. American International College, Springfield, Massachusetts, 1992. Selected Paintings from the Kosciuszko Foundation Collection, Museum of Fine Arts, St. Petersburg, Florida, 1994.

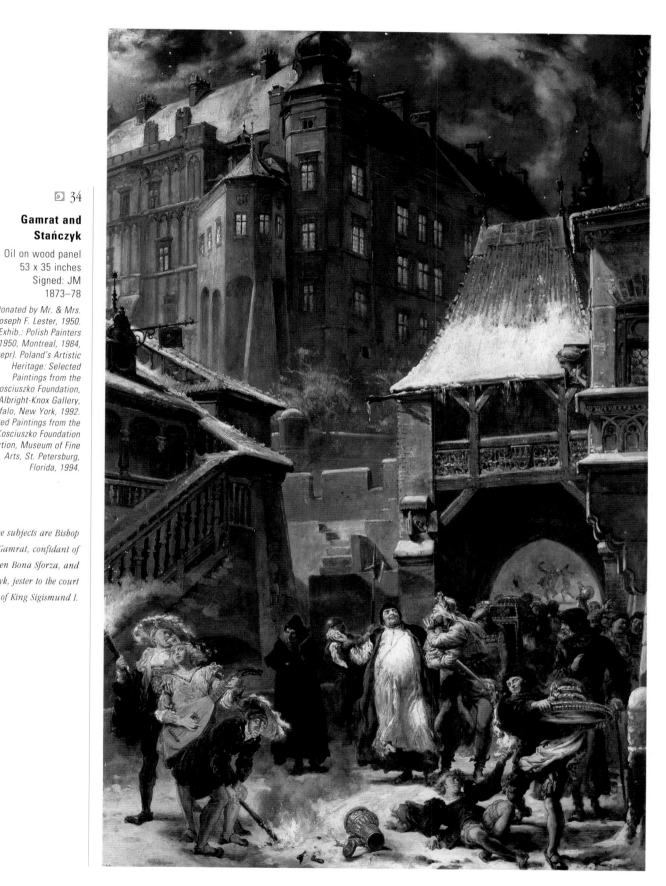

⚕ JAN MATEJKO

born June 24, 1838, in Kraków
died November 1, 1893, in Kraków

⊙ 34

**Gamrat and
Stańczyk**

Oil on wood panel
53 x 35 inches
Signed: JM
1873–78

*Donated by Mr. & Mrs.
Joseph F. Lester, 1950.
Exhib.: Polish Painters
1850–1950, Montreal, 1984,
(repr). Poland's Artistic
Heritage: Selected
Paintings from the
Kosciuszko Foundation,
Albright-Knox Gallery,
Buffalo, New York, 1992.
Selected Paintings from the
Kosciuszko Foundation
Collection, Museum of Fine
Arts, St. Petersburg,
Florida, 1994.*

*The subjects are Bishop
Gamrat, confidant of
Queen Bona Sforza, and
Stańczyk, jester to the court
of King Sigismund I.*

Matejko's father was a music teacher of Czech ancestry; his mother was from a bourgeois Kraków family. His formal training under Wojciech Korneli Stattler and Władysław Łuszczkiewicz at the Kraków School of Fine Arts (1852 -1858) was supplemented by study with Hermann Anschültz in Munich and Carl Ruben in Vienna. Although he made a number of trips abroad, to Paris (1867, 1870, 1880), Prague (1873), Budapest (1873), and Constantinople (1873), Matejko lived and worked his entire life in Kraków, where he was professor and later rector at the School of Fine Arts. After 1887 he spent considerable time at his estate, Krzestawice, near Myslenice.

Matejko is Poland's greatest historical painter. Among his best-known panoramic compositions are *Skarga's Sermon, Rejtan, The Union of Lublin, Batory at Pskov, The Battle of Grunwald, The Prussian Homage,* and *Jan Sobieski at Vienna.* He also painted smaller historical genre scenes and portraits of well-known Kraków personages, as well as more intimate and psychologically penetrating character studies, such as the splendid *Self-Portrait* of 1892.

Matejko took great pains with historical accuracy, and he collected period artifacts in his studio. In addition to his major works, many sketch books have survived that attest to his skilled hand, solid craftsmanship, and attentiveness to detail. Many of his drawings were published in albums—*Polish Costumes* and *Portraits of Polish Kings,* for example.

Throughout his life, Matejko fought to preserve Kraków's historical landmarks, including the Church of Saint Mary, the Cloth Hall, and Wawel Castle. With his students Stanisław Wyspiański and Józef Mehoffer, he executed the mural in the Church of Saint Mary (1889–1891) that has long been recognized as one of the greatest examples of Polish monumental art.

Matejko was a member of many foreign academies, including both the Paris and the Berlin Academy of Art and the French Institute. In 1887 he received an honorary doctorate from the Jagiellonian University in Kraków. His works were exhibited often in Poland and several European capitals, and he was the recipient of many medals, awards, and decorations.

On October 29, 1878, Matejko was presented with a royal scepter in Wawel Castle, a symbol of his reign over Polish art and the hearts of his countrymen. After his death, his house on Saint Florian Street, "Matejko House," was transformed into a museum, with its original furnishings and collections preserved and a selection of his work exhibited.

BIBLIOGRAPHY

I. Witkiewicz, *Matejko* (Lwów-Warsaw, 1908); Mieczysław Treter, *Jan Matejko* (Lwów, 1939); Jan Gintel, *Jan Matejko: Biografia w wypisach ze wstepem...* (Kraków, 1955); Krystyna Sroczyńska, *Jan Matejko* (Warsaw, 1966); Janusz M. Michałowski, *Jan Matejko* (Warsaw, 1973); Juliusz Starzyński, *Jan Matejko* (Warsaw, 1979); Janusz M. Michałowski, *Jan Matejko* (Warsaw, 1980); Janusz Michałowski, *Jan Matejko: Portrety* (Warsaw, 1987).

✺ ALEKSANDER ORŁOWSKI

born March 9, 1777, in Warsaw
died March 13, 1832, in St. Petersburg

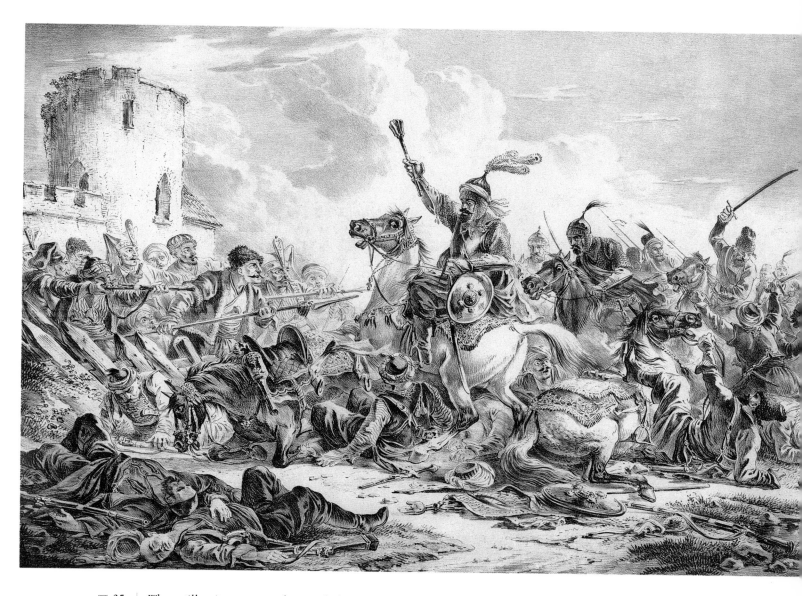

35

The Battle

Lithograph on paper
20 x 30 inches
Signed: A. Orłowski
St. Petersburg, 1829

*Donated in memory of
Bronisław Podczaski by Dr.
Clara L. Grochowska.*

When still quite young, perhaps with the support of art patron Izabela Czartoryska, Orłowski was accepted as a student by the painter Jan Piotr Norblin. He was probably also connected with the studio of Marcello Bacciarelli, and he learned engraving from Bartholomew Folino. He is said to have participated in the Kościuszko Insurrection of 1794, during which he made numerous drawings of the scythe-bearing peasant troops, Kościuszko's soldiers, and likenesses of the commander himself. For a time he belonged to the intimate circle of Prince Józef Poniatowski, for whom he painted portraits and thematic works and drafted satires and caricatures for the entertainment of the company at the Pałac pod Blahą ("Palace under the Tin Roof"). The summer of 1799 found him at Nieborów, where he designed variations of neo-Gothic and antique structures for Princess Helena Radziwiłłowa's "Arcadia" park.

In 1802 Orłowski left for Saint Petersburg, where he became court painter to Grand Duke Constantine Pavlovich. Here he made many drawings and watercolor portraits, some with a humorous or satirical tinge.

Various fashionable Masonic lodges in the Russian capital welcomed him as a member, and in 1809 he became a member of the Saint Petersburg Academy of Art. In 1819 he began making prints, aquatints and lithographs for the Military-Topographical Staff of the Russian Army.

Orłowski's oeuvre, then, includes pen and ink drawings; charcoal sketches; drawings in pencil, crayon, watercolor, and gouache; oils; pastels; and aquatints and lithographs. It embraces both historical and contemporary military scenes, peasant and noble types, portraits and self-portraits, village genre scenes, landscapes, and studies of horses and weapons. He enjoyed painting Polish and Russian folk life, often introducing exotic figures—Bashkirs, Circassians, Kirghizians, and Persians.

BIBLIOGRAPHY

Władysław Tatarkiewicz, *Aleksander Orłowski* (Warsaw, 1926); Helena Blumówna, *Aleksander Orłowski* (Warsaw, 1953); Helena Cekalska-Zborowska, *Aleksander Orłowski* (Warsaw, 1962); Halina Nelken, "Aleksander Orłowski: The Works of a Great Polish Painter in American Collections," *Polish Review 3* (1976).

MARCIN FRANCISZEK SAMLICKI

born October 23, 1878, in Bochnia
died June 25, 1945, in Bochnia

⊡ 36

**The Old Wooden
Church**

Oil on canvas
26 x 21 inches
Signed: Samlicki 1932

*Donated by Dr. Anthony
Mallek, 1960.
Exhib.: Polish Painters
1850–1950, Montreal, 1984
(repr.). Poland's Artistic
Heritage: Selected
Paintings from the
Kosciuszko Foundation,
Albright-Knox Gallery,
Buffalo, New York, 1992.
American International
College, Springfield,
Massachusetts, 1992.
Selected Paintings from the
Kosciuszko Foundation
Collection, Museum of Fine
Arts, St. Petersburg,
Florida, 1994.*

*The architecture is typical
of rural churches of
southern Poland.*

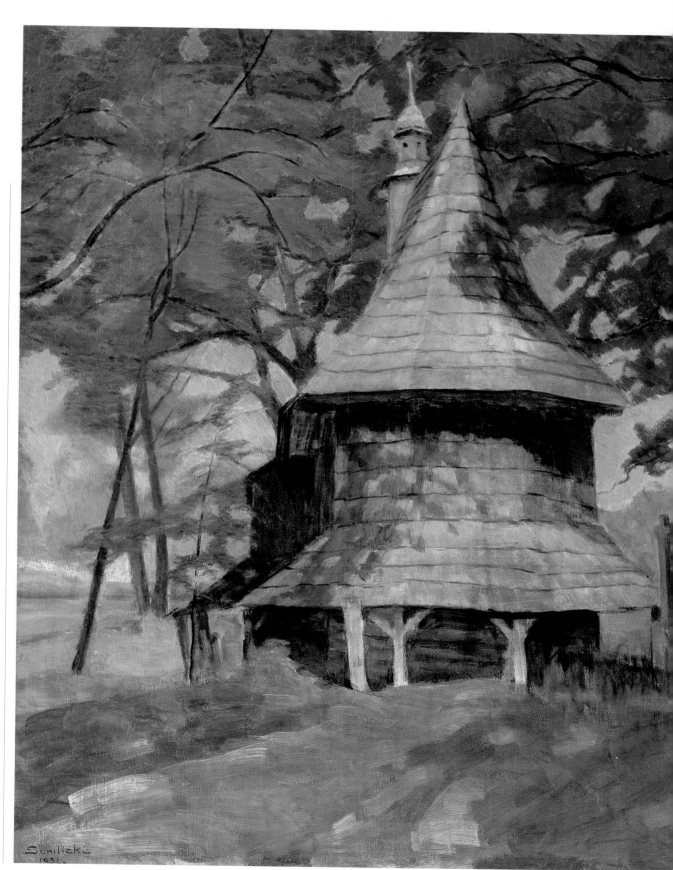

Samlicki studied art at the Kraków Academy of Fine Arts under Józef Mehoffer, Jacek Malczewski, Jan Stanisławski, and Józef Unierzyski. He taught drawing in Kraków for two years (1911–1912) and spent the next seven years in Paris, except for a period of internment in the south of France as a prisoner of war (because of his Austrian citizenship). He settled in his native Bochnia in 1929 but traveled extensively throughout Europe; in 1933 he made a trip to the United States. He was a member of the "Plastyka" Association of Poznań Artists and of the Kraków "Group of Ten." He exhibited often with both groups, especially in Warsaw, Kraków, and Poznań.

Samlicki painted landscapes, genre scenes, and portraits. His work can be found in museums in Warsaw, Kraków, Katowice, Tarnów, and Prague, and in private collections abroad.

Samlicki was also a critic; he published in the Kraków periodicals *Kurier Literacko-Naukowy, Sztuki Piękne,* and *Rydwan.* He was author of a monograph on Józef Mehoffer (Kraków, 1922).

37

The Pink Road

Oil on board
10 x 14 inches
Signed: Samlicki, 1933

Donated by Mrs. Beatrice A. Tolodziecki.

born April 18, 1858, in Lwów
died April 28, 1925, in Rome

⊡ 38

**Kościuszko at the
Battle of
Racławice**

Oil on canvas
51 x 38 inches
Signed: Jan Styka
ca. 1894

*Acquired from Mr. Edward
S. Witkowski.
Exhib.: Polish Painters
1850–1950, Montreal, 1984
(repr.). Poland's Artistic
Heritage: Selected
Paintings from the
Kosciuszko Foundation,
Albright-Knox Gallery,
Buffalo, New York, 1992.
American International
College, Springfield,
Massachusetts, 1992.
Embassy of the Republic of
Poland, Washington, D.C.,
1994.*

*This work is a study for
Styka's famous panorama*
The Battle of Racławice.

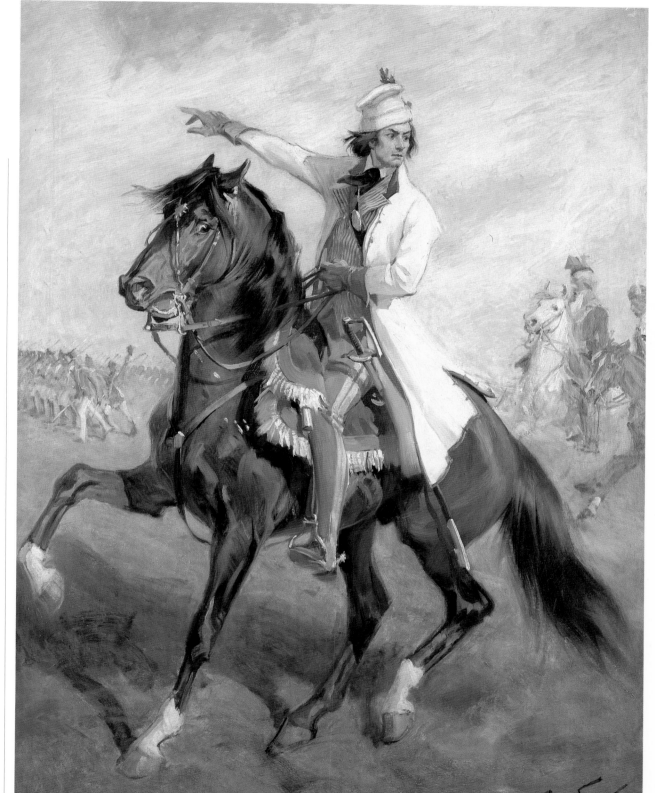

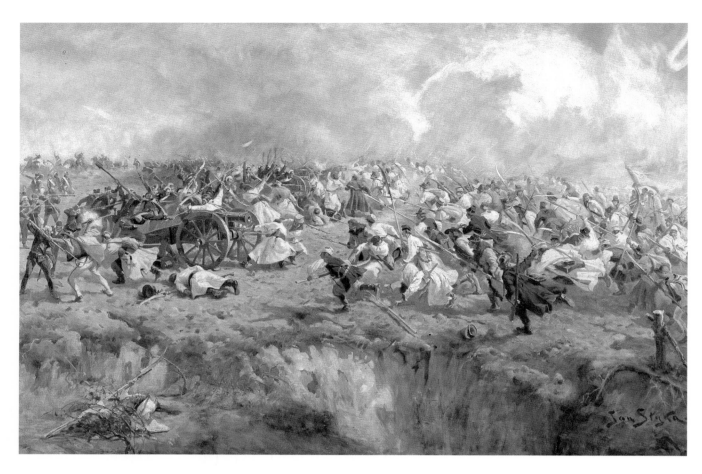

74

Styka studied at the Vienna Academy of Fine Arts (1877 -1881) under I. Müllera and C. Wurzinger. He continued his studies in Rome (1881) and at the Kraków School of Fine Arts under Jan Matejko (1882–1885). After a three-year stay in Paris (1886–1889), he returned to Poland, finally settling in Lwów. In 1900, however, he moved permanently to Paris. Styka owned a villa on the isle of Capri where he hoped to create a museum of his own works, but the plan was never realized. He traveled widely throughout Europe, making a trip through Greece and Italy in 1912. In Rome he became a member of the Art Academy of Saint Luke.

Styka painted historical, military, and religious scenes as well as portraits. He also occasionally made illustrations for books and periodicals. He is best known, however, for his collaboration with such painters as Jan Stanisławski, Tadeusz Popiel, Zygmunt Rodakowski, and Michal Wywiórski in the creation of historical and religious panoramas. These include *Golgotha* (1896; presently located in Los Angeles), *General*

Bem in Transylvania (1896), and *The Martyrdom of the First Christians* (1899). He and Wojciech Kossak jointly executed *The Battle of Racławice* (1892 -1894); he also designed *The Battle of Grunwald* with his son Tadeusz Styka. The panoramas were exhibited widely in Warsaw, Budapest, Moscow, Chicago, and Paris. Other works by Styka were exhibited in Poland and abroad, often together with those of his sons Adam and Tadeusz.

BIBLIOGRAPHY

Aleksander Małaczyński, *Jan Styka,* (Lwów 1930); Czesław Czapliński, *The Styka Family Saga* (New York, 1988)

🖸 39

Peasants Capturing the Cannon at Racławice

Oil on canvas
35 x 55 inches
Signed: Jan Styka
ca. 1894

Gift of Casimir A. Silski, 1973.
Exhib.: Poland's Artistic Heritage: Selected Paintings from the Kosciuszko Foundation, Albright-Knox Gallery, Buffalo, New York, 1992. Selected Paintings from the Kosciuszko Foundation Collection, Museum of Fine Arts, St. Petersburg, Florida, 1994.

Also a sectional study for The Battle of Racławice, *this composition depicts the dramatic moment of victory, with Kościuszko instructing his troops, armed with scythes, to take a Russian battery.*

TADEUSZ STYKA

born April 12, 1889, in Kielce
died in 1954, in New York

🖻 40

**Portrait of Anne
Koons Parrish**

Oil on canvas
48 x 36 inches
Signed: Tade Styka
ca. 1935

*Donated by Miss Mary
Koons in memory of her
sister, Anne Koons Parrish.*

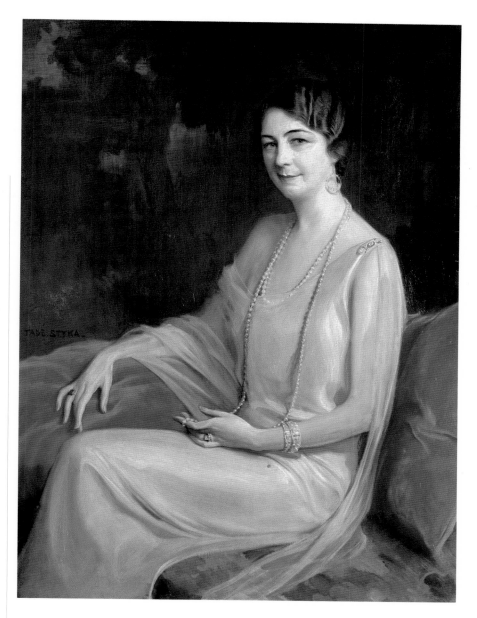

Tadeusz Styka studied first in his father Jan Styka's studio and then in Paris under Jean Jacques Henner and Eugène Carrière. He exhibited his work for the first time in Paris at the age of eleven. Styka painted mostly portraits—political figures, aristocrats, artists, and renowned beauties. In 1904 he was acclaimed at the Salon des artistes for his portraits of Enrico Caruso, Fyodor Chaliapin, Pola Negri, and Ignacy Paderewski. He had numerous exhibitions in major cities, including Paris (two at the Galerie Georges Petit), Warsaw, Łódź, New York (Wildenstein Gallery), Montreal, Toronto, and Buenos Aires. He often exhibited jointly with his brother Adam. The majority of Styka's works are in collections in New York. A portrait of J. J. Henner and a treatment of the Prometheus theme are in the Molhouse Museum. His Portrait of Sarah Delano Roosevelt (1936), mother of Franklin Delano Roosevelt, is on permanent exhibit at the Roosevelt estate at Hyde Park, New York.

BIBLIOGRAPHY

Czesław Czapliński, *The Styka Family Saga* (New York, 1988).

WŁADYSŁAW SZERNER

born June 3, 1836, in Warsaw
died January 4, 1915, in Unter-Haching, near Munich

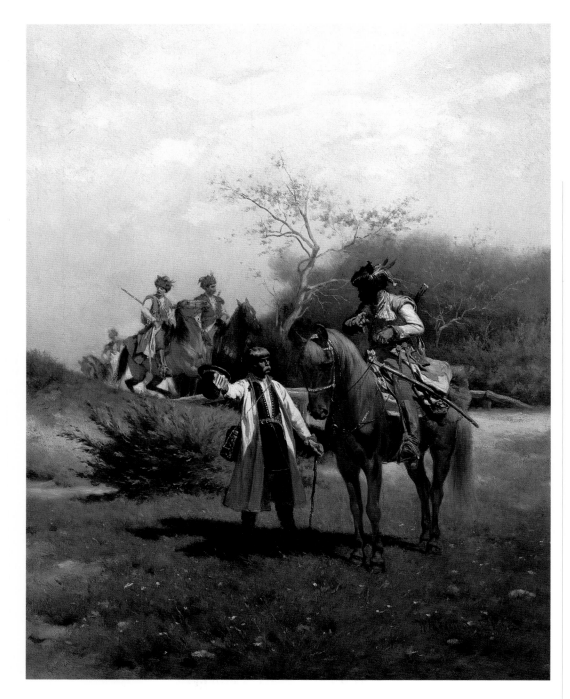

◎ 41

**A Reconnoitering
Expedition**

Oil on canvas
20 x 16 inches
Signed:
Władysław Szerner
ca. 1870

*Donated by Mr. & Mrs.
Peter P. Yolles.
Exhib.: Polish Painters
1850–1950, Montreal, 1984
(repr.). Poland's Artistic
Heritage: Selected
Paintings from the
Kosciuszko Foundation,
Albright-Knox Gallery,
Buffalo, New York, 1992.
American International
College, Springfield,
Massachusetts, 1992.
Selected Paintings from the
Kosciuszko Foundation
Collection, Museum of Fine
Arts, St. Petersburg,
Florida, 1994.*

Szerner studied at the Nobleman's Institute in Warsaw from 1850 to 1854 and at the Warsaw School of Fine Arts. In 1865 he enrolled in the Munich Academy, were his teachers were Hermann Anschütz, Alexander Strähuber, and Alexander Wagner. He also joined the studio of Józef Brandt, who was a major influence. Szerner never returned to Poland but did contribute his works to Polish exhibitions, including that of the "Zachęta" Society of Fine Arts in Warsaw in 1870. He painted landscapes, historical works, and genre scenes from village life (for example, *Hutzul Women Riding to a Wedding* and *Village Fair*). Szerner's paintings are in the collections of museums in Warsaw, Kraków, Poznań, and Lwów.

BIBLIOGRAPHY
M. Zakrzewska, Obrazy Malarzy Polskich, *Biuletyn Historii Sztuki 3* (1961).

WŁODZIMIERZ PRZERWA TETMAJER

born December 31, 1861, in Ludzmierz near Nowy Targ
died December 26, 1923, in Kraków

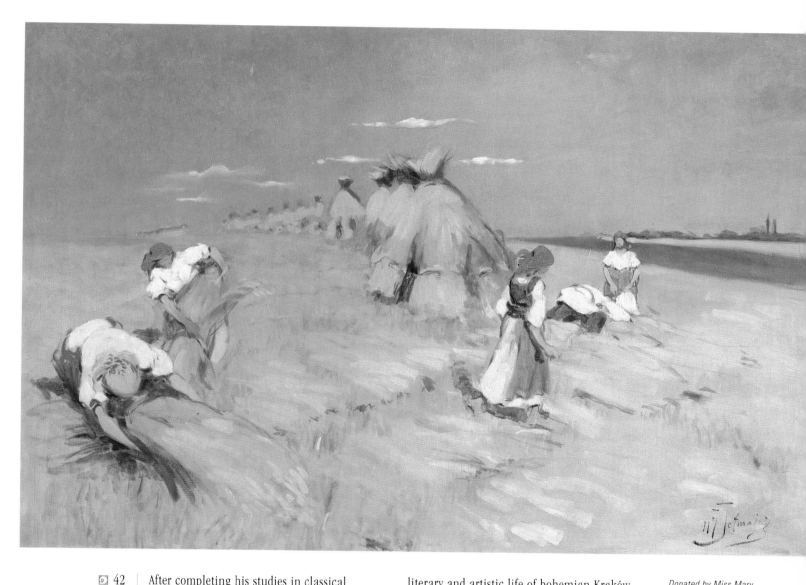

🖾 42

The Harvest

Oil on canvas
26 x 40 inches
Signed: Wl. Tetmajer
ca. 1905

After completing his studies in classical philology at the Jagiellonian University, Tetmajer enrolled at the Kraków School of Fine Arts (1875–1886) and then later studied privately under Władysław Łuszczkiewicz, Florian Cynk, and Jan Matejko (1889–1895). The intervening period was spent in Vienna and Munich, where he worked with Alexander Wagner, and in Paris at the Académie Colarossi. By 1890 he had his own studio in Kraków.

After his marriage to Anna Mikołajczykówna, daughter of a local peasant, Tetmajer settled permanently in the village of Bronowice near Kraków. His house became the center of the literary and artistic life of bohemian Kraków and a "summer school" for plein-air painting for students of the Kraków Academy.

Tetmajer was a cofounder of the "Sztuka" Society of Polish Artists and participated in its exhibitions in Poland and abroad. In 1901 he cofounded the Society of Polish Applied Art, and that same year, together with Jan Bukowski, he established the Kraków School of Fine Arts and Artistic Industry for Women. In 1908 he was one of the organizers of the art group "Zero."

Tetmajer painted primarily landscapes and genre scenes, focusing particularly on the

Donated by Miss Mary Głowacki.
Exhib.: Polish Painters 1850–1950, Montreal, 1984 (repr.). Poland's Artistic Heritage: Selected Paintings from the Kosciuszko Foundation, Albright-Knox Gallery, Buffalo, New York, 1992. American International College, Springfield, Massachusetts, 1992. Selected Paintings from the Kosciuszko Foundation Collection, Museum of Fine Arts, St. Petersburg, Florida, 1994.

scenery and customs of the rural areas around Kraków. His works were known for their lively composition and vivid colors. He also executed several polychromes, in which he combined folk motifs and an art nouveau style, as well as occasional stage designs and book illustrations.

A political activist affiliated with the Polish peasant party "Piast," Tetmajer served as a delegate to the Austrian parliament from 1911 to 1918. Stepbrother of the poet Kazimierz Tetmajer, he was also the author of poems, articles, and political treatises, which were printed in the Kraków periodical *Czas* and collected in 1923 under the title *Political Writings.*

BIBLIOGRAPHY

Jan Czernecki, *Włodzimierz Tetmajer* (Kraków, 1911); Józef Duzyk, *Sława Panie Włodzimierzu: Opowieść o Włodzimierzu Tetmajerze* (Warsaw, 1972).

❧ LEON WYCZÓŁKOWSKI

born April 11, 1852, in Huta Miastowska near Garwolin
died December 27, 1936, in Warsaw

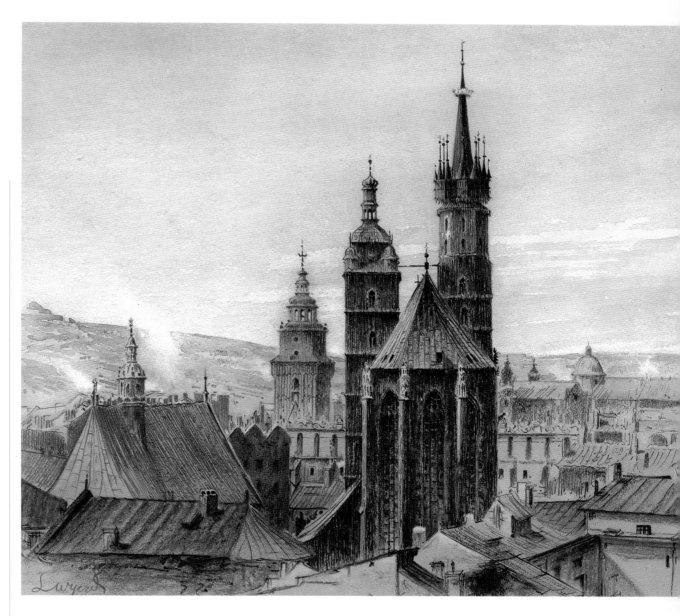

🖻 43

Saint Mary's Church in Kraków

Watercolor and charcoal
on paper
20 x 23 inches
Signed:
L. Wyczółkowski
1926

*Donated by Mr. Adam B. Lyczak.
Exhib.: Polish Painters 1850–1950, Montreal, 1984 (repr.). Poland's Artistic Heritage: Selected Paintings from the Kosciuszko Foundation, Albright-Knox Gallery, Buffalo, New York, 1992. Selected Paintings from the Kosciuszko Foundation Collection, Museum of Fine Arts, St. Petersburg, Florida, 1994.*

Wyczółkowski studied initially in the Warsaw Drawing Class (1869–1871) under Aleksander Kamiński, Rafał Hadziewicz, and Wojciech Gerson. He continued his studies at the Munich Academy (1875–1877) under Alexander Wagner and at the Kraków School of Fine Arts (1877–1879) under Jan Matejko. Wyczółkowski lived in the Ukraine from 1883 to 1893, and in later years he spent much of his time on his estate, Gościeradz, in the Bydgoszcz area. From 1895 to 1911 he was a professor at the Kraków Academy of Fine Arts, and in 1934 he became professor of graphics at the Warsaw Academy of Fine Arts. He was a founding member of the 'Sztuka' Society of Polish Artists and took part in numerous exhibitions in Poland and abroad. In 1920 he received the State Award for Art and in 1930 the Award of the City of Warsaw. He was also honored with the Order of Polonia Restituta.

Wyczółkowski is reckoned among the foremost Polish artists at the turn of the century. He first painted mainly portraits and elegant salon interiors in the mode of

☐ 44

Poet's Sweetheart

Pastel on paper
24 x 13 inches
Signed:
L. Wyczółkowski
(upper left inscription:
P. Skrzynskiemu -
L. Wyczółkowski)
ca. 1901

*Exhib.: Polish Painters 1850
–1950, Montreal, 1984
(repr.). Poland's Artistic
Heritage: Selected
Paintings from the
Kosciuszko Foundation,
Albright-Knox Gallery,
Buffalo, New York, 1992.
American International
College, Springfield,
Massachusetts, 1992.
Selected Paintings from the
Kosciuszko Foundation
Collection, Museum of Fine
Arts, St. Petersburg,
Florida, 1994.*

*The model is a peasant girl
from Bronowice, near
Kraków, Jadwiga
Mikolajczyk, bride of the
Polish poet Lucjan Rydel.
The two were
commemorated by
Stanislaw Wyspianski in his
play* The Wedding *(1901).*

nineteenth-century realism. During his long stay in the Ukraine, he concentrated on landscape studies, and this work culminated in a series of brilliantly colored, light-filled pictures devoted to scenes of planting, harvesting, and fishing. His work thus drew close to the impressionism he had first encountered in Paris in 1878, although a symbolist strain is sometimes discernible, as, for example, in *Sarcophagi* (1897). Wyczółkowski also painted portraits and self-portraits, genre and historical scenes, still lifes, and floral compositions famous for their beauty. He worked in pastel and water-color as well as oils. In 1910 he virtually abandoned painting for graphics, especially color lithography, and left a handsome legacy of graphic work, most of it collected in thematic portfolios such as *The Tatras* (1906), *Lithuanian Portfolio* (1907), *Hutzul Portfolio* (1910), *Wawel I and II* (1911/1912), *Old Warsaw* (1916), and *Impressions from Białowieza* (1922). Wyczółkowski's paintings can be found in all larger Polish museums (the largest collection is in the museum bearing his name in Bydgoszcz) and in private collections in Poland, France, England, Austria, Germany, and the United States.

BIBLIOGRAPHY

Maria Twarowska, ed., *Leon Wyczółkowski: Listy i wspomnienia* (Wrocław, 1960), Maria Twarowska, *Leon Wyczółkowski* (Warsaw, 1962, 1973).

THE KOSCIUSZKO FOUNDATION:
AN AMERICAN CENTER FOR POLISH CULTURE

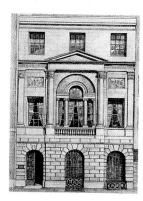

Facade, Kosciuszko
Foundation House,
W. T. & Basia Benda,
pencil on paper, 1946.

The Kosciuszko Foundation is dedicated to promoting educational and cultural exchanges between the United States and Poland and to increasing American understanding of Polish culture and history.

Founded in 1925, on the eve of the 150th anniversary of Tadeusz Kościuszko's enlistment in the American revolutionary cause, the Foundation is a national not-for-profit, nonpartisan, and nonsectarian organization. Headquartered in New York City, the Foundation has chapters in Buffalo, Chicago, Denver, Houston, Philadelphia, and Pittsburgh.

The Kosciuszko Foundation's primary activity is the disbursement of fellowships, scholarships, and grants. These are awarded to Polish academics, scholars and artists for independent research and studies in the United States, to American students for Year Abroad Language and Culture studies in Poland and American academics for postdoctoral study in Poland, and to graduate students in the United States who are of Polish descent and to American students pursuing Polish studies. The Foundation also organizes summer language and culture study programs at Polish universities and, in conjunction with UNESCO of Poland, conducts English-language immersion programs for high-school students in Poland.

Each season the Foundation sponsors a variety of artistic programs—lectures, readings, concerts, and exhibitions—meant to explore and reflect upon the Foundation's mission of promoting Polish culture. In New York, the events are held at the Foundation House, the landmark building in the heart of Manhattan's Upper East Side. Its intimate concert hall is also the Gallery of Polish Masters, the exhibition space for the Foundation's exceptional collection of nineteenth and twentieth century Polish artworks. The Foundation's acclaimed annual Chopin Piano Competition has uncovered many great talents, including Van Cliburn and Murray Perahia, and the monthly Chamber Music Series is broadcast by WQXR, New York, in one of the country's few remaining regularly scheduled radio programs of live classical music.

The Kosciuszko Foundation is a 501(c)(3) membership organization supported by contributions from foundations, corporations, and individuals who share in its mission of fostering relations and understanding between the United States and Poland.

APPENDIX: A PARTIAL LISTING OF WORKS IN THE COLLECTION OF THE KOSCIUSZKO FOUNDATION

PAINTINGS I.

ARTYMOWSKA, ZOFIA (1923–)

POLIFORMY - LXX - 1
oil on canvas, 51.75 x 29.25 inches

POLIFORMY LXXIX
oil on canvas, 22.75 x 31 inches

AUGUSTYNOWICZ, ALEKSANDER (1865–1944)

Portrait of Felicja Stachowicz-Grek ▣ 1
oil on canvas, 39 x 30 inches
Gift of the Estate of Robert Perutz

AXENTOWICZ, TEODOR (1859–1938)

The Blessing of the Waters among the Hutzuls ▣ 2
oil on canvas, 101 x 130 inches

Spring and Winter ▣ 3
pastel on cardboard, 20 x 27 inches
Gift of Drs. Jan & Irene Dobrowolski, 1994

BAKAŁOWICZ, WŁADYSLAW (1833–1903)

Portrait of a Lady ▣ 4
oil on wood, 12 x 9 inches

BENDA, WŁADYSŁAW TEODOR (1873–1948)

Before the Storm ▣ 5
oil on canvas, 64 x 37 inches
Gift of Mrs. & Mrs. John J. Sokolowski, 1952

Polish Dance, Krakowiak ▣ 6
pastel and colored crayon on cardboard
25 x 40 inches
Gift of the artist

Tadeusz Kościuszko
tempera on cardboard, 35.5 x 32.5 inches
Gift of Mrs. W.T. Benda, 1965

Highlander Dance ▣ 7
pastel on cardboard
25 x 30 inches
Gift of the artist

Jadwiga, Queen of Poland
pastel on cardboard, 22 x 19.75 inches
Gift of the artist

Tadeusz Kościuszko
pastel, colored crayon and pencil on cardboard
22 x 19.75 inches
Gift of the artist

Kościuszko on Horseback
pastel and colored crayon on cardboard
19.75 x 19.75 inches (oval on top)

Crazy Horse
colored crayon and gouache on cardboard
20.5 x 20.25 inches
Gift of the artist

Janosik
colored crayon, watercolor and pencil on cardboard, 19.5 x 18 inches
Gift of the artist

Chopin
pastel and gouache on cardboard
17.75 x16 inches
Gift of the artist

Kościuszko between Poland and America
charcoal drawing on paper, 18.5 x 19.5 inches
Gift of the artist

Girl in Tulips
pastel and colored crayon on cardboard
16.75 x 13.25 inches
Gift of the artist

Girl in Daisies
pastel and colored crayon on cardboard
16.25 x 12.5 inches
Gift of the artist

Mother Earth
colored crayon on cardboard
21.25 x 20.5 inches
Gift of Mme. Ganna Walska, 1954

T. Kościuszko
Tempera and colored pencil on cardboard
35.5 x 32.5 inches
Gift of Mrs. W.T. Benda, 1965

BERDYSZAK, JAN (1934–)

In Silence
wood construction, 39.5 x 39.5 inches

BŁOCKI, WŁODZIMIERZ (1885–1920)

Man with a Cigarette
gouache on cardboard, 39.25 x 27 inches

BOZNAŃSKA, OLGA (1865–1940)

Woman in a Blue Dress ▣ 8
oil on cardboard, 38 x 28 inches
Gift of Mr. & Mrs. Alexander R. Koproski, 1977

BRANDT, JÓZEF (1841–1915)

Light Cavalry, Lisowczycy ▣ 9
oil on canvas, 42 x 35 inches
Gift of Mr. & Mrs. Stanley Kupiszewski, 1958

CHEŁMINSKI, JAN (1851–1925)

His Last Vision ▣ 10
oil on canvas, 32 x 22 inches
Gift of Mme. Jan de Chełminski, 1950

CHEŁMOŃSKI, JÓZEF (1849–1914)

Country Fair ▣ 11
oil on canvas, 23 x 27 inches
Gift of Miss Mary R. Koons in memory of her
sisters: Anne Koons Parrish and Mrs. John
Bonin, 1968

CHMIELIŃSKI, WŁADYSŁAW (1911–1979)

Cracovian Wedding
oil on canvas, 16.25 x 20 inches
Gift of Dr. & Mrs. Joseph Kostecki, 1975

CZACHÓRSKI, WŁADYSŁAW (1850–1911)

Young Lady at the Fireplace ▣ 12
oil on canvas, 21 x 32 inches
Gift of Dr. Walter M. Golaski in memory of his
wife Helene Dolores Golaski, 1968

CZEDEKOWSKI, BOLESŁAW (1885–1969)

Kościuszko at West Point ▣ 13
oil on canvas, 72 x 60 inches
Gift of the artist, 1947

CZERMAŃSKI, ZDZISŁAW (1896–1970)

Artur Rubinstein
pen, ink and gouache on paper, 28 x 22 inches

Jan Lechoń
charcoal and wash on paper, 25 x 19 inches
Gift of Wanda Roehr, 1969

Portrait of J. Piłsudski
charcoal on cardboard, 39 x 24 inches
Gift of Mrs. Beatrice Tolodzieski, 1978

DAMEL, JAN (1780–1840)

Kościuszko Released from Russian Prison ▣ 14
oil on canvas, 99 x 70 inches
Gift of Dr. Anthony S. Mallek in memory of his
parents, Szczepan & Agnieszka Mallek, 1951

DŁUBAK, ZBIGNIEW (1921–)

MOVENS - 13
oil on wood panel, 36.5 x 24.5 inches

FAŁAT, JULIAN (1853–1929)

Saint Anne's Church in Warsaw ▣ 15
watercolor on board, 27 x 20 inches
Gift of Mr. Casimir A. Silski, 1951

FRYDRYSIAK, BERNARD (1908–1970)

Portrait of Henry Noble McCracken
oil on canvas, 52 x 36 inches
Gift of the artist

Portrait of Prof. Stephen P. Mizwa ▣ 16
oil on canvas, 46 x 36 inches
Gift of the artist

Portrait George C. Marshall
oil on canvas, 38 x 29 inches
Gift of the artist

Portrait of D. Hammerskjold
oil on canvas, 30 x 24 inches
Gift of the artist

GRAMATYKA, ANTONI (1841–1922)

Sisters of Charity with Orphans ▣ 17
oil on board, 11 x 16 inches
Gift of Mr. Frank Lukas-Lukasiewicz

GRYGLEWSKI, ALEKSANDER
(1833–1879) and MATEJKO,
JAN (1838–1893)

Interior of a Church ▣ 18
oil on canvas, 36 x 29 inches
Gift of Mrs. W. Sidney Felton in memory of her
mother Marianna Szczechowicz, 1955

GWOZDECKI, GUSTAW (1880–1935)

French Riviera ▣ 19
oil on board, 10 x 13 inches

HOFFMAN, VLASTIMIL (1881–1970)

Saint Christopher and the Child Jesus
▣ 22
oil on composition board, 22 x 19 inches
Gift of the artist, 1961

KANTOR, TADEUSZ (1915–1990)

Cracovie, I
oil on canvas, 35 x 45.75 inches

Cracovie II
oil on canvas, 31.5 x 39 inches

KĘDZIERSKI, APOLONIUSZ (1861–1939)

The Old Oaken Bucket ▣ 23
oil on canvas laid on wood, 17 x 22 inches
Gift of friends in memory of "Wladzia" Alice
Aszurkiewicz, 1969

KOBZDEJ, ALEKSANDER (1920–1972)

United
oil on canvas, 53.5 x 39.5 inches

KOSSAK, JERZY (1886–1955)

The Three Heros
oil on canvas, 46.75 x 39.25 inches

The Retreat
oil on cardboard, 15 x 19.5 inches

Polish Uhlan and Russian Cossack ▣ 26
oil on cardboard, 8.25 x 12.25 inches
Gift of Mrs. W. Sidney Felton

KOSSAK, JULIUSZ (1824–1899)

The Dzieduszycki Stable ▣ 24
watercolor on paper, 14 x 23 inches
Gift of Mme. Ganna Walska, 1954

KOSSAK, WOJCIECH (1856–1942)

Napoleon Crossing the Berezyna in 1812
oil on canvas, 35.5 x 29.75 inches
Gift of Rev. Joseph Tamilowski

Polish Legionnaire of 1916
oil on wood panel, 19.5 x 15.5 inches
Gift Mme. Ganna Walska

The Knight and the Maid ▣ 25
oil on canvas, 46 x 39 inches
Gift of Dr. & Mrs. John A. Cetner in memory of
Edward & Jeanette Witkowski

The Prisoners
oil on canvas laid on masonite
11.75 x 14 inches

Youthful Defender of Lvov
oil on cardboard, 15.75 x 11.75 inches
Gift of friends in memory of "Wladzia", Alice
Aszurkiewicz, 1969

The Legonnaire
oil on canvas laid on masonite
14.5 x 11.5 inches
Gift of Dr. Gilda Podczaski in memory of
Bronisław Podczaski

KOSSOWSKI, ADAM (20th century)

gouaches
series of twelve scenes depicting Polish prison-
ers labor camp in Siberia in 1940, each titled in
Polish on reverse, each signed and dated 1943.

KOSTRZEWSKI, FRANCISZEK
(1826–1911)

The Apple Orchard ▣ 27
oil on canvas laid on masonite, 20 x 30 inches
Gift of Mr. Kazimierz Jarzębowski for his wife
Florentyna, 1959

KOTSIS, ALEKSANDER (1836–1877)

Polish Mountaineer ▣ 28
oil on canvas, 18 x 12 inches
Gift of friends in memory of "Władzia" Alice
Aszurkiewicz, 1969

LEBENSTEIN, JAN (1930–)

Figure No. 84
oil on canvas, 63.5 x 51.25 inches

Figure No. 103
oil on canvas, 58 x 35 inches

LEWADOWSKA, ANIELA (1896–1953)

Still Life with Blossoms ▣ 31
oil on canvas, 23 x 28 inches
Gift of Mr. George Szabad

MAKIELSKI, LEON (20th century)

Portrait of Samuel M. Vauclain
oil on canvas, 40.25 x 32 inches
Gift of the artist

MALCZEWSKI, JACEK (1854–1929)

Self Portrait with a Black Hat ▣ 32
oil on cardboard, 19 x 13 inches

The Final Journey ▣ 33
oil on canvas, 25 x 44 inches
Gift of John Malinowski in memory of his
mother Mrs. Zofia Malinowska, 1951

MATEJKO, JAN (1838–1893)

Gamrat and Stańczyk ▣ 34
oil on wood panel, 53 x 35 inches
Gift of Mr. & Mrs. Joseph F. Lester, 1950

SAMLICKI, MARCIN (1878–1945)

Lipnica Murowana
oil on cardboard, 15 x 18 inches
Gift of Dr. A. Mallek

The Pink Road ▣ 37
oil on board, 10 x 14 inches
Gift of Mrs. Beatrice A. Tolodziecki

Landscape with Trees
oil on cardboard, 13.5 x 10 inches
Gift of Mrs. Beatrice A. Tolodziecki

The Old Wooden Church ▣ 36
oil on canvas, 26 x 21 inches
Gift of Dr. Anthony Mallek, 1960

Country Houses
oil on canvas, 17.75 x 20.5 inches

STYKA, JAN (1858–1925)

*Peasants Capturing the Cannon
at Racławice* ▣ 39
oil on canvas, 35 x 55 inches
Gift of Casimir A. Silski, 1973

*Kościuszko at the Battle of
Racławice* ▣ 38
oil on canvas, 51 x 38 inches
Acquired from Mr. Edward S. Witkowski

STYKA, TADEUSZ (1889–1954)

Portrait of a Lady
oil on canvas, 31.75 x 25.5 inches

Portrait of Anne Koons Parrish ▣ 40
oil on canvas, 48 x 36 inches
Gift of Miss Mary Koons in memory of her
sister, Anne Koons Parrish

SUDNIK, GEORGE (1886–1948)

Portrait of Gen. Wladimir Krzyzanowski
oil on canvas, 36 x 25 inches
Gift of Mr. & Mrs. Thomas S. Brunowski in
memory of Genevieve A. Brunowski Mizwa,
1962

SZERNER, WŁADYSŁAW (1836–1915)

A Reconnoitering Expedition ▣ 41
oil on canvas, 20 x 16 inches
Gift of Mr. & Mrs. Peter P. Yolles

SZYK, ARTUR

Polish Peasants
pen and ink drawing, 5.5 x 6 inches
Gift of Mrs. Helen Hoinko Ouchterloney, 1994

Polish Peasant Destroying Nazi Dragon
pen and ink drawing, 9 x 7.25 inches
Gift of Mrs. Helen Hoinko Ouchterloney, 1994

TETMAJER, WŁODZIMIERZ (1861–1923)

The Harvest ▣ 42
oil on canvas, 26 x 40 inches
Gift of Miss Mary Głowacki

WANIEK, HENRYK (1942–)

Improwizacja (876)
watercolor on paper, 13 x 17 inches

WIERUSZ-KOWALSKI, ALFRED
(1849–1915)

The Horse Fair ▣ 30
oil on wood panel, 12 x 24 inches
Gift of Mr. & Mrs. Jan Janowski, 1958

On the Farm ▣ 29
oil on cardboard, 20 x 27 inches
Gift of Mr. & Mrs. Joseph Kluz, 1951

WINIARSKI, RYSZARD (contemporary)

Mechanizm Strefy
wood and masonite construction
29 x 29 x 4.75 inches

WYCZÓŁKOWSKI, LEON (1852–1936)

Saint Mary's Church in Krakow ▣ 43
watercolor and charcoal on paper
20 x 23 inches
Gift of Mr. Adam B. Lyczak

Poet's Sweetheart ▣ 44
pastel on paper, 24 x 13 inches

ZAKRZEWSKI, WŁODZIMIERZ
(contemporary)

Street in Poland
oil on cardboard, 11.25 x 8.25 inches

PAINTINGS II.

ARTIST UNKNOWN

Portrait of Kościuszko
oil on canvas, 22 x 19 inches
Gift of Mr. Leslie Burgess, 1990

AIWASOVSKI, IVAN (1817–1900)
attributed
At the Shore
oil on cardboard, 3.75 x 11.25 inches
From the Estate of Prof. Sophie Wojciechowski

BENDA, EMILIA M. (20th century)
gouache on paper
group of four paintings, each signed, also titled
in Polish on reverse:
Jasełka, 10 x 14 inches
Sobótki, 14.4 x 9.5 inches
Narciarze, 14 x 20 inches
Procesja Bozego Ciała, 14 x 20 inches

BURASIEWICZ, TOMASZ
(contemporary)
oil on canvas, 46.5 x 67.75 inches
signed: lower right: T. Burasiewicz / V 83 /
BUFFALO

CZORBA, TIBOR (Hungarian,
20th century)
Monastery on the Lake Wigry
watercolor, 14 x 18 inches
Gift of the artist

DELAPORTE, GUY (20th century)
*Interior of the Grand Salon, 15 East
65th Street*
oil on canvas, 25.5 x 30.75 inches

Sitting Room, 15 East 65th Street
oil on canvas, 25.5 x 30.75 inches

GWOZDECKI, GUSTAW (1880–1935)
Head of a Woman 20
Nude 21
pencil on paper
group of forty drawings - 32 female heads and
8 female nudes
average size 8.5 x 11 inches

JANIKOWSKI, MIECZYSŁAW
(1912–1968)
Abstract Composition in Blue
oil on wood, 5.75 x 4.25 inches
Gift of Ms. A. Janikowski, sister of the artist

Abstract Composition in Brown
oil on wood, 3.75 x 5.75 inches
Gift of Ms. A. Janikowski, sister of the artist

KALM, CHET (contemporary)
City Without a Name
oil on canvas, 14.25 x 20.5 inches
Gift of the artist, 1994

KARKOWSKI, RICHARD (contemporary)
Two Marigolds
watercolor, 11.5 x 8 inches
Gift of the artist

KNUTH, ROBERT (1952–)
oil on paper, 20 x 30 inches

mixed technique on paper, 20 x 30 inches

mixed technique and collage on paper,
19.75 x 14.25 inches

LIPIŃSKI, L. (20th century)
pencil on paper
series of five drawings depicting interiors of
the Kosciuszko Foundation in New York City,
each signed, ca 1947
15 x 20 inches each

LORENTOWICZ, IRENA (1908–1985)
Polonaise
oil on canvas, 35.5 x 26 inches
Gift of the artist

MACIUCH, JAN M. (contemporary)
Jesień nad Sanem III
watercolor on paper, 9 x 12 inches
pen and ink drawing on paper, 14 x 9.75 inches

MARS, WITOLD T. (1912–1985)
Warwick Street, London
oil on canvas, 24 x 21 inches
Gift of Mrs. Helen Mars

MENKES, ZYGMUNT (1896–1986)
Standing Nude
pencil drawing, 12 x 7 inches
Gift of the artist's wife

Standing Nude with Raised Arms
pencil drawing, 12 x 8 inches
Gift of the artist's wife

Standing Nude
pencil drawing, 12.25 x 7.75 inches
Gift of the artist's wife

PABISIAK, Z. (20th century)
Royal Portrait
oil on wood, 21 x 15.5 inches

ROMANS, CHARLES (Romanowski,
Casimir) (b. 1891)
Moonlight Reverie
oil on canvas, 24.75 x 29.5 inches
Gift of Mrs. Helen Romans

SZYSZKO, FELIKS (1940–)
Eight Days of the Week
colored pencil on paper, 23 x 27 inches
Gift of the artist

TYNIEC, JAN (contemporary)
Koniec Wieku 19867
oil on canvas, 39.5 x 54.25 inches
Gift of the artist

WISNIEWSKI, STANISŁAW (1936–)
Pejzaz
oil on canvas, 22 x 26 inches

abstract composition
oil on canvas, 45.75 x 35.25 inches
Gift of the artist

WRÓBEL, P. (20th century)
Funeral
oil on masonite, 26.5 x 19.5 inches

ZEBROWSKI, JULIAN (contemporary)
Wieczór ku czci Lechonia
ink on paper, 22 x 13.75 inches
signed: lower right: J. Zebrowski (monogram) 76

KOŚCIUSZKO PRINTS*

*Thaddeus Kościuszko / Polsk
Falthearre - J.F. Martin del. et. sc. 1797*
engraving, 15 x 21.5 cm

Kościuszko / grave p. C. Pfeiffer
(early 19th century)
engraving, 23 x 16 cm

*Taddeo Cociucso Generalle Pollacco - G.B.
Bossio dis. - G.A. Sasso inc.*
(early 19th century)
engraving, 17 x 11.5 cm

*Tadeusz Kościuszko - W.J. Benzdorf w
Krakowie - nr 3522*
(mid. 19th century)
color lithograph, 30 x 26 cm

Kościuszko - engraved by W. Hall ... 1829
engraving, 11.5 x 9.5 cm

*Kościuszko - from a print by A.
Oleszczynski - engraved by W. Hall*
(early 19th century)
engraving (2 prints), 12.5 x 10 cm

*Kościuszko - lith. by Delpech, facsimile sig-
nature of Kościuszko (circa 1840)*
lithograph, hand colored, 9 x 8 cm

Kościuszko - F.B. Hall printed by W. Pata
(early 19th century)
engraving, 13 x 10 cm

Thadeus Kościuszko
(mid. 19th century)
engraving, 10 x 8.5 cm

*Thaddeus Kościuszko / Engraved by
William Sharp from a model in wax done
from the life by C. Andras*
(early 19th century)
engraving, 30 x 38 cm

Kościuszko - J.F. Schruter
engraving, diameter: 6 cm

Kościuszko - F. Bonneville - G. Marray
(end of 18th century)
engraving, 11 x 8.8 cm

*Thaddeus Kościuszko - I. Grassi pinx - G.
Taubert del - G. Flesinger*
(early 19th century)
engraving, 20.5 x 17.5 cm (oval)

*Kościuszko Generalissimo - Venezia presso
Antonio Zatta e Figli*
(end of 18th century)
engraving, 13.5 x 8.7 cm

General Kościuszko - J. Chapman
(end of 18th century)
engraving, 11.2 x 9 cm (oval)

Kościuszko
(French, circa 1840)
lithograph, 9 x 9 cm

*Thaddeus Kościuszko - Garnum - lith.
Ducarme, 1817 (?)*
lithograph, 12 x 11 cm

*Thade Kościuszko - Joseph Grassi pinx
Kurowski del - de la coll. L. Chodzko -
James Hopwood sc., Paris 1840*
engraving (2 prints), 11 x 9 cm

*La Montagne de Kościuszko - Carolus
Hoffman pinx A. Oleszczynski sculpt 1820*
engraving, 19.5 x 16.5 cm

Kościuszko - Bortonnier 1828
engraving, hand colored, 13 x 80 cm